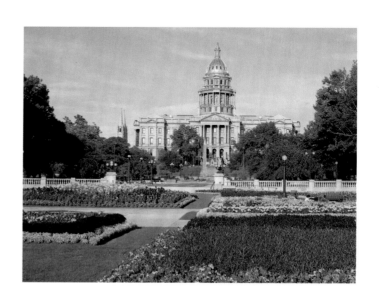

# DENVER

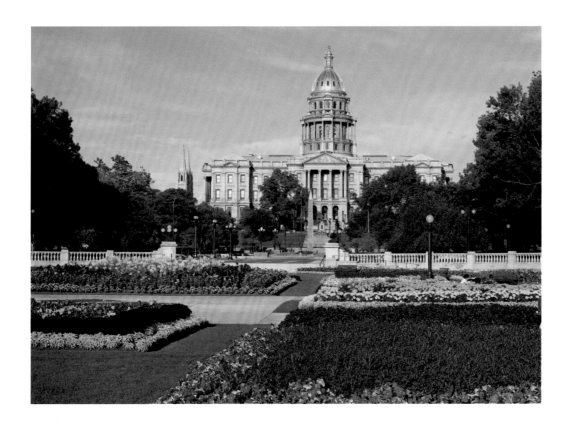

WHITECAP BOOKS

Text by Tanya Lloyd Kyi
Edited by Elaine Jones
Photo editing by Tanya Lloyd Kyi
Proofread by Lisa Collins
Cover and interior layout by Jacqui Thomas

Printed and bound in Canada

**National Library of Canada Cataloguing in Publication Data**

Kyi, Tanya Lloyd, 1973–
    Denver

    (America series)
    ISBN 1-55285-414-0

    1. Denver (Colo.)—Pictorial works.  I. Title.  II. Series:Kyi, Tanya Lloyd, 1973—
America series.
F784.D443K94 2003        978.8'83034'0222        C2002-911394-6

The publisher acknowledges the support of the Canada Council and the Cultural
Services Branch of the Government of British Columbia in making this publication
possible. We acknowledge the financial support of the Government of Canada through
the Book Publishing Industry Development Program for our publishing activities.

For more information on the America Series and other Whitecap Books
titles, please visit our web site at www.whitecap.ca.

Today's metropolis of 2.4 million people bears little trace of the mining camp that sprang up here in 1859. Like other boom towns, Denver attracted its share of prospectors and prostitutes, gun-fighters and saloon-keepers. But unlike other Wild West towns, Denver's boom never went bust. Money from the mines was soon pouring not into dance halls, but into public works. Industry barons and entrepreneurs set aside parkland, sponsored sculptures and fountains, and built ornate hillside mansions. Soon the Queen City of the Plains was one of America's most sophisticated centers. Presidents holidayed here and international dignitaries flew in for high tea.

Denver now attracts 8.8 million visitors each year with a seemingly endless array of festivals, sights, and attractions. In a single day, sightseers can wander from the luxurious gold rush–inspired Brown Palace Hotel to the modern architecture of the Denver Public Library. They can drink in the riotous sounds of the country's largest Cinco de Mayo celebration or quietly contemplate the extensive collection of native art at the Denver Art Museum. Finally, they can crown the day with a stop in LoDo, the city's entertainment district, or with a view of the state capitol's gilded dome at sunset.

Rising behind the state capitol are the mountains that make Colorado—and Denver—unique. It's no surprise that city residents are some of the fittest people in America. Here, business moguls metamorphose into mountain bikers each evening. Shoppers browse for designer labels on Mondays and hiking boots on Fridays. And visitors to the Mile High City find countless activities to lure them outside, from boating on City Park's Ferril Lake to rock climbing in nearby Rocky Mountain National Park. From these outdoor escapes to the heart of the city's history, this book explores the many facets of Denver, Colorado.

In 1876, Colorado became the thirty-eighth state to join the Union. It was five more years before a referendum confirmed Denver as the state capital, and another nine before crews laid the 20-ton cornerstone of the capitol building. The structure, built one mile above sea level, was completed in 1908 with the gilding of its dome.

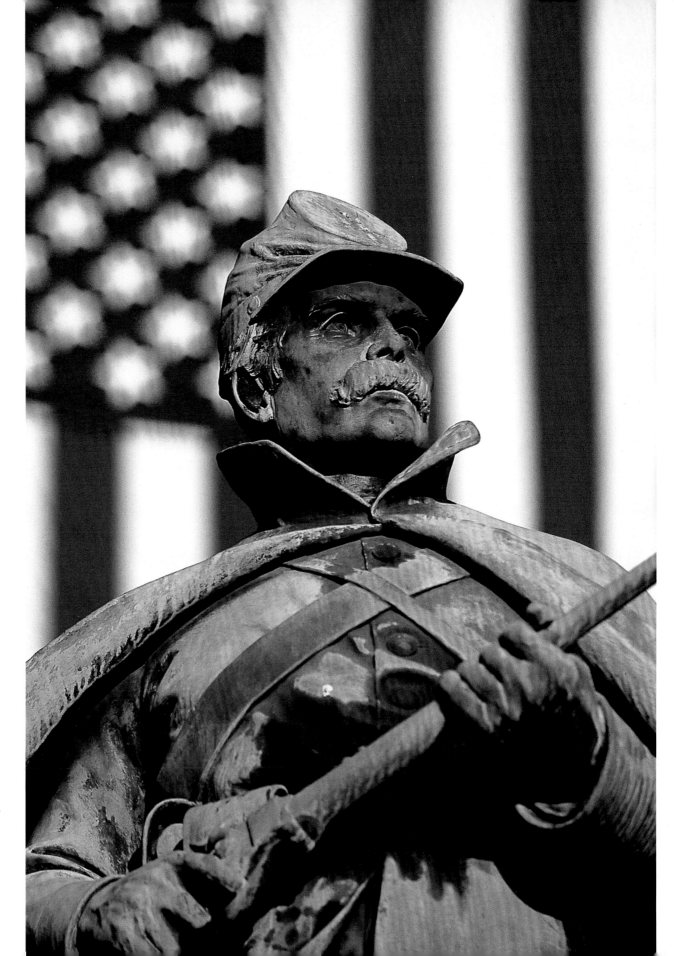

Bearing the names of
soldiers killed in battle,
this bronze sculpture of
a Union Soldier facing
south was created
by Captain John D.
Howland, a member
of the 1st Colorado
Cavalry, and J. Otto
Schweizer of Philadelphia.
It was unveiled in 1909.

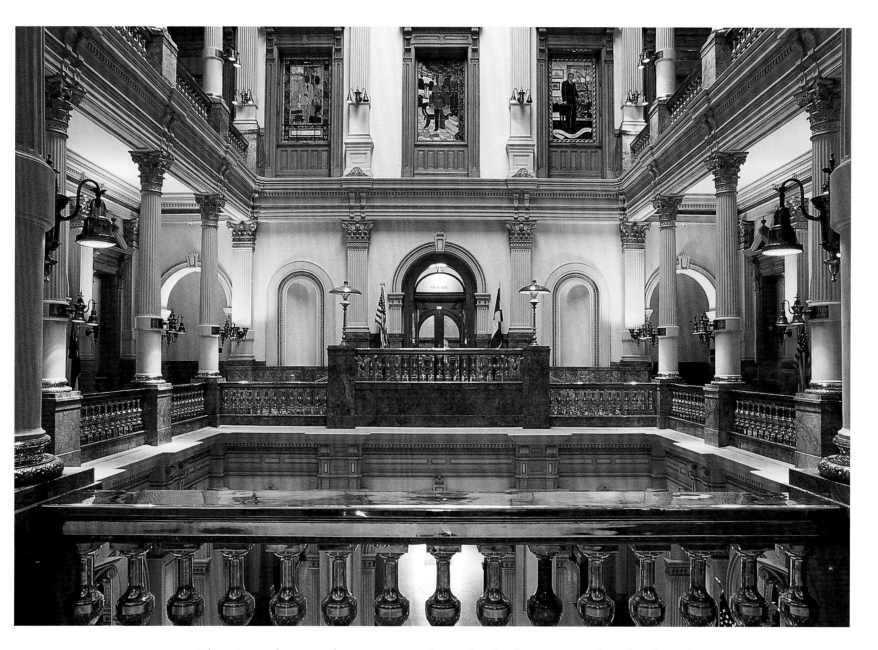

The Corinthian-style state capitol was built almost entirely of Colorado materials, from the sandstone foundations to the rose onyx finishings. The elaborate chandeliers were originally designed to burn gas, as the builders of the time didn't trust the reliability of the newly available electric power. The last chandelier was converted to electricity in 1930.

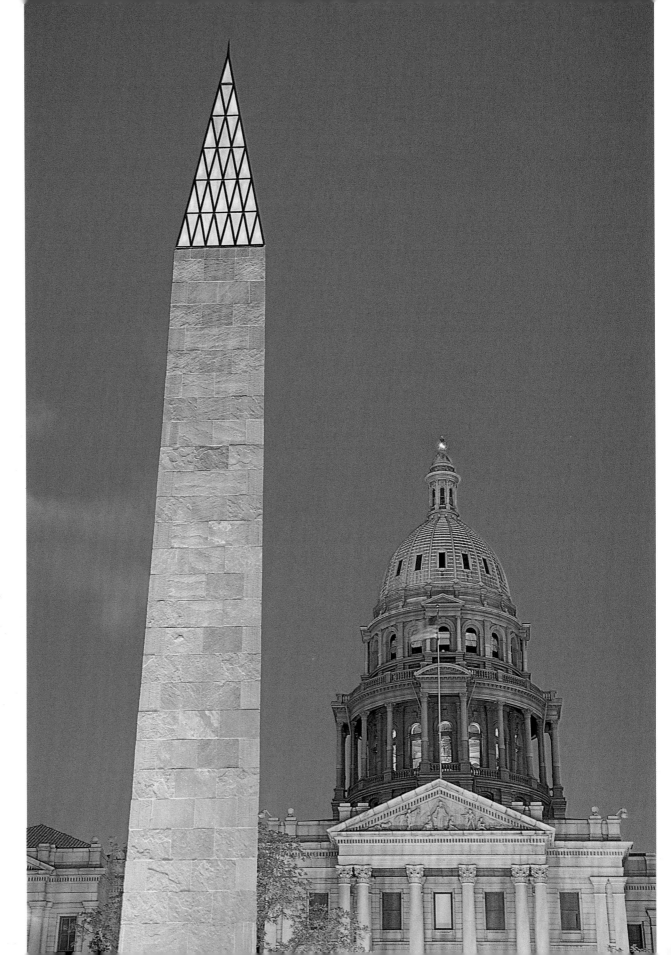

Colorado's Veterans Monument was designed by Robert Koot and Richard Farley, part of a state-wide contest judged by a committee of veterans. The sandstone tower signifies strength and vigilance, while the crowning beacon symbolizes lasting awareness and memory.

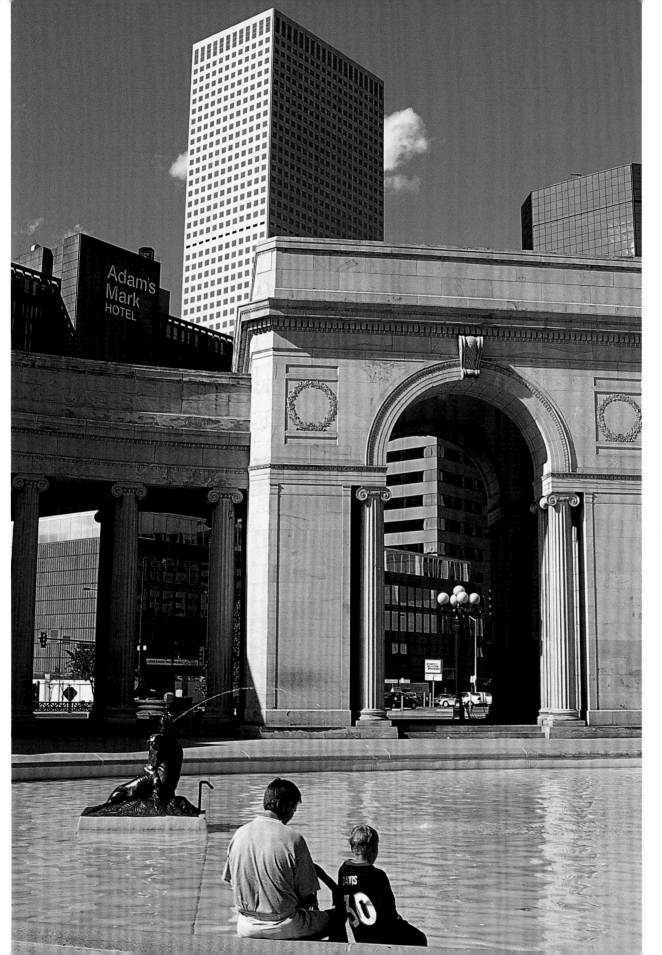

Designed in 1914 by Frederick Law Olmsted, Jr., Civic Center Park spans the heart of Denver and links the state capitol, the City and County Building, the Denver Art Museum, and the Denver Public Library. The park is a popular stage for special events, from the Cinco de Mayo celebrations each May to the Taste of Colorado festival, which marks the end of summer.

11

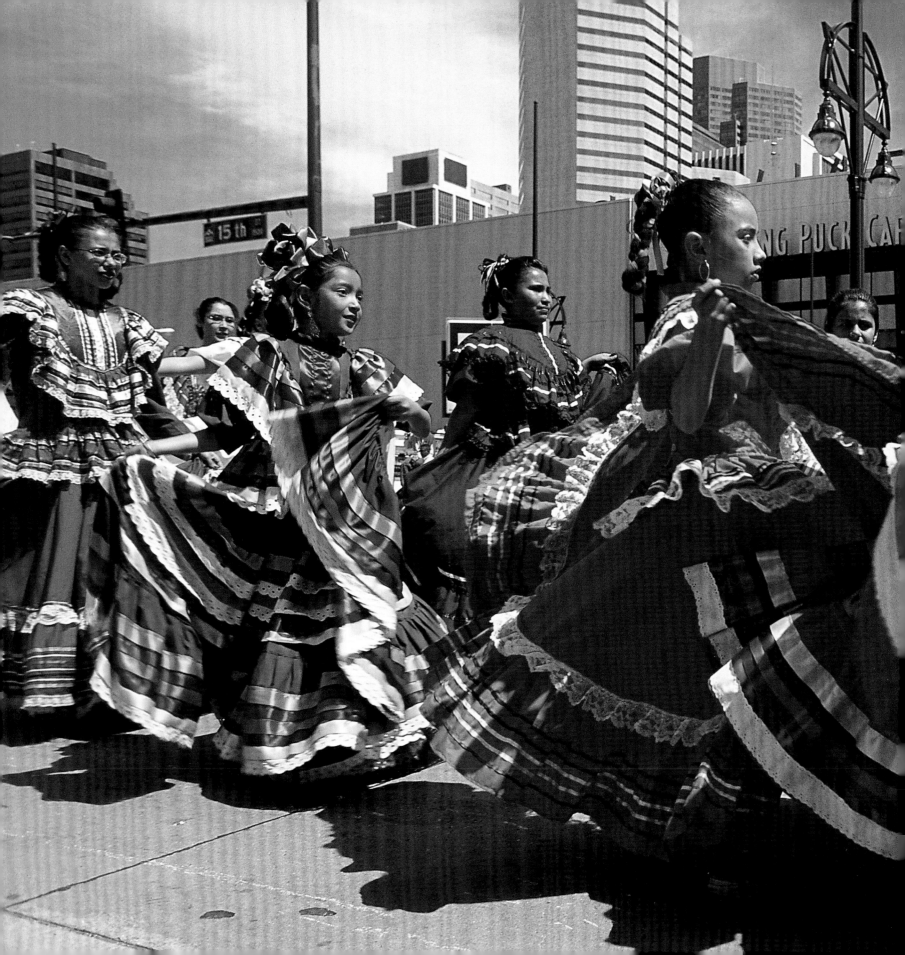

More than 400,000 people flock to Civic Center Park each May for the Cinco de Mayo celebrations. A day of national pride for people of Mexican descent, the festival marks the anniversary of the Battle of Puebla, where Mexican fighters defended the town against a French force three times larger. In Denver, festivities include a parade, outdoor concerts, food kiosks, and art displays.

Created by Gio Ponti of Italy and James Sudler Associates of Denver, the Denver Art Museum is a 28-sided, seven-story gallery clad in more than a million specially designed gray tiles. Within the unique structure are 48,000 works of art, including sculpture, architecture, painting, textiles, and photography.

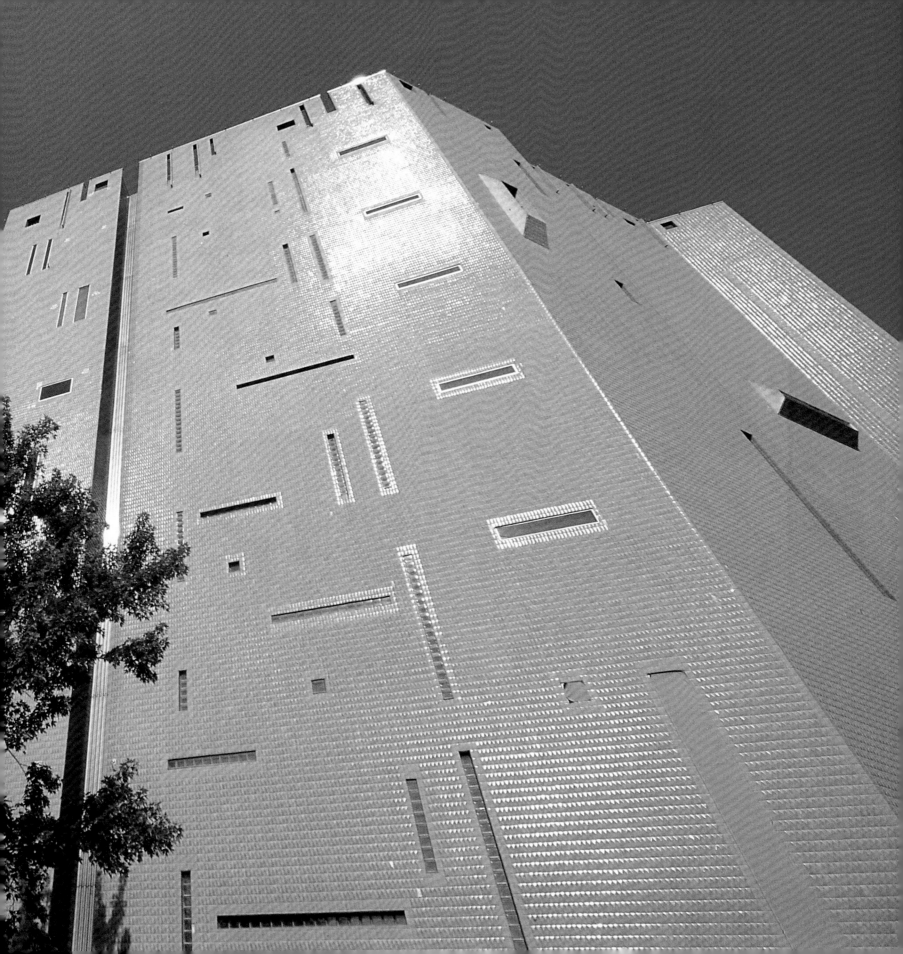

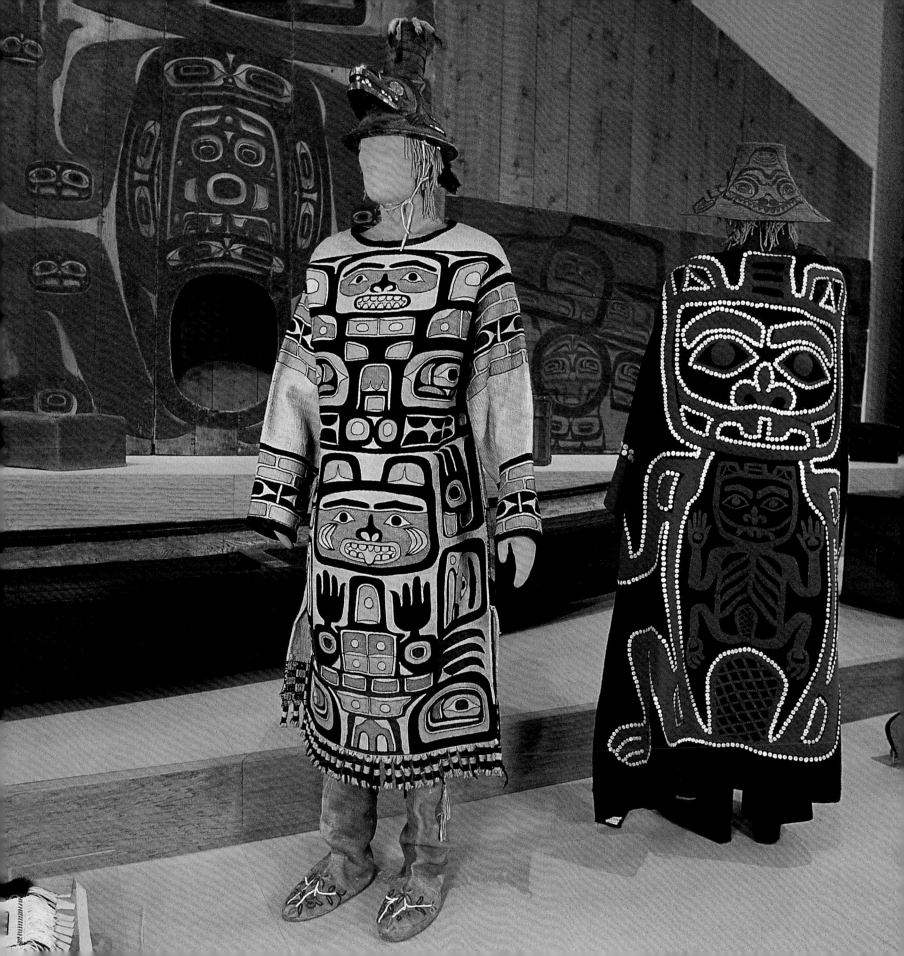

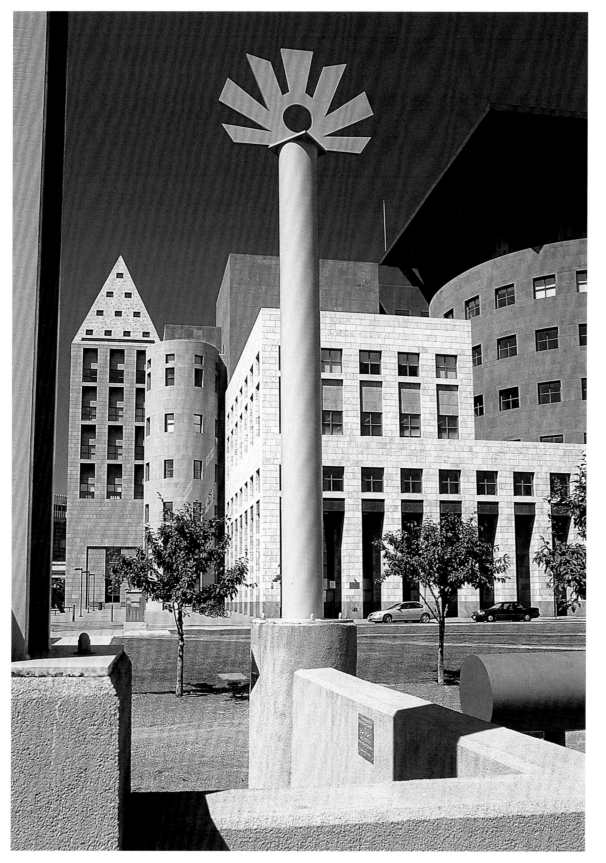

Completed in 1995, the Denver Public Library anchors a system of 22 branches throughout the city. The largest public library between Los Angeles and Chicago, the building was designed by renowned architect Michael Graves, who also planned the renovation of the U.S. Courthouse and the restoration of the Washington Monument in Washington, D.C.

FACING PAGE
The Denver Art Museum holds one of the world's largest collections of Native American arts. More than 16,000 pieces include Plains Indian beadwork, Navajo weaving, and Pueblo pottery.

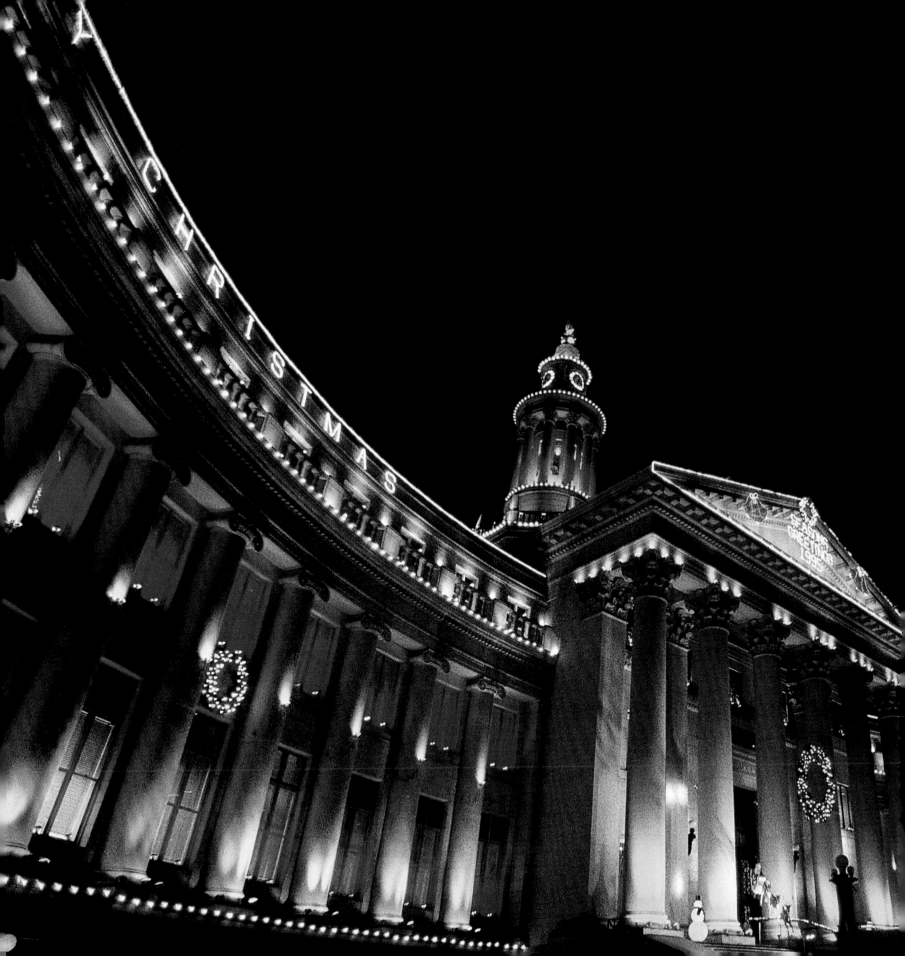

Designed by a coalition of 39 local architects, Denver's City and County Building took 26 years to build and was completed in 1932. During the holiday season, 20,000 lights bedeck the structure, supported by five miles of electrical wire.

19

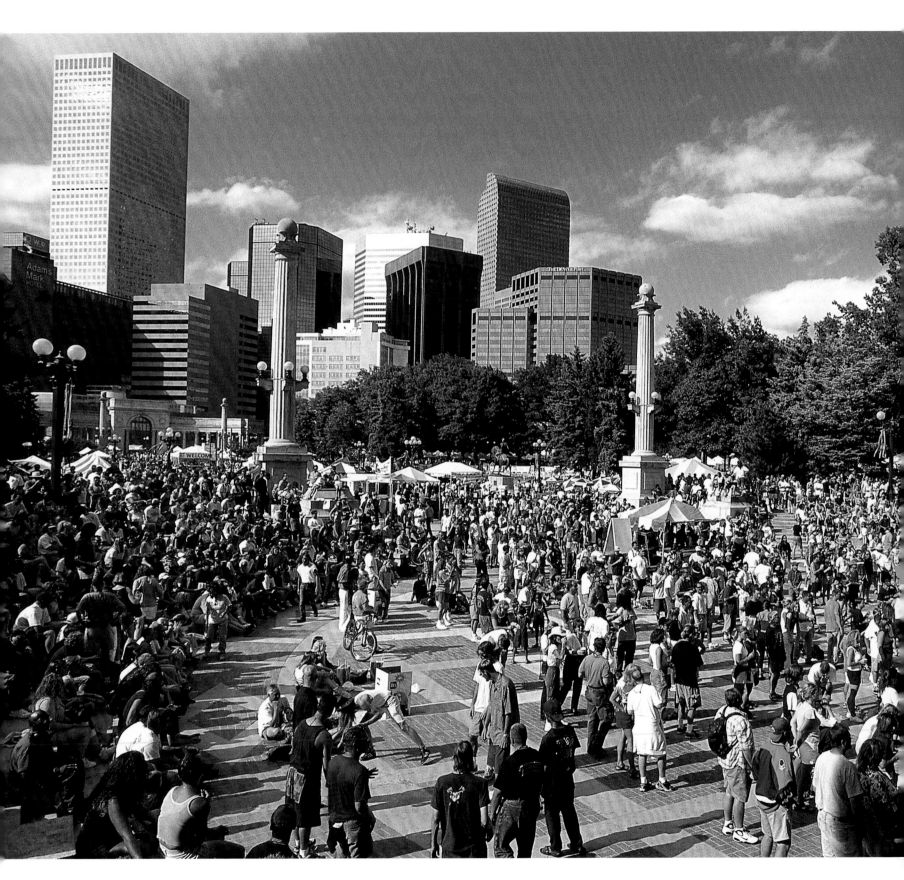

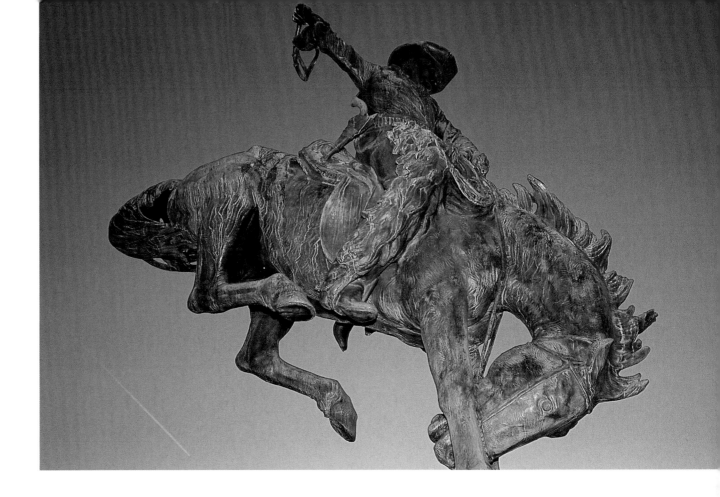

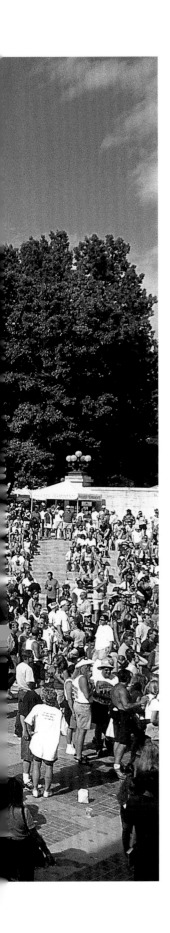

According to local legend, sculptor Alexander Phimister Proctor asked a cowboy to model for his sculpture *Bronco Buster*. When the cowboy was arrested for murder, Proctor cajoled the sheriff into allowing the completion of the project before jailing the model. The sculpture is on display in Civic Center Park.

Designed to reflect Denver's diversity, the Capitol Hill People's Fair is staged with the help of 600 volunteers and includes hundreds of booths and exhibits. More than 250,000 people attend the festivities, grazing among the food stands or enjoying dance and musical performances on six stages.

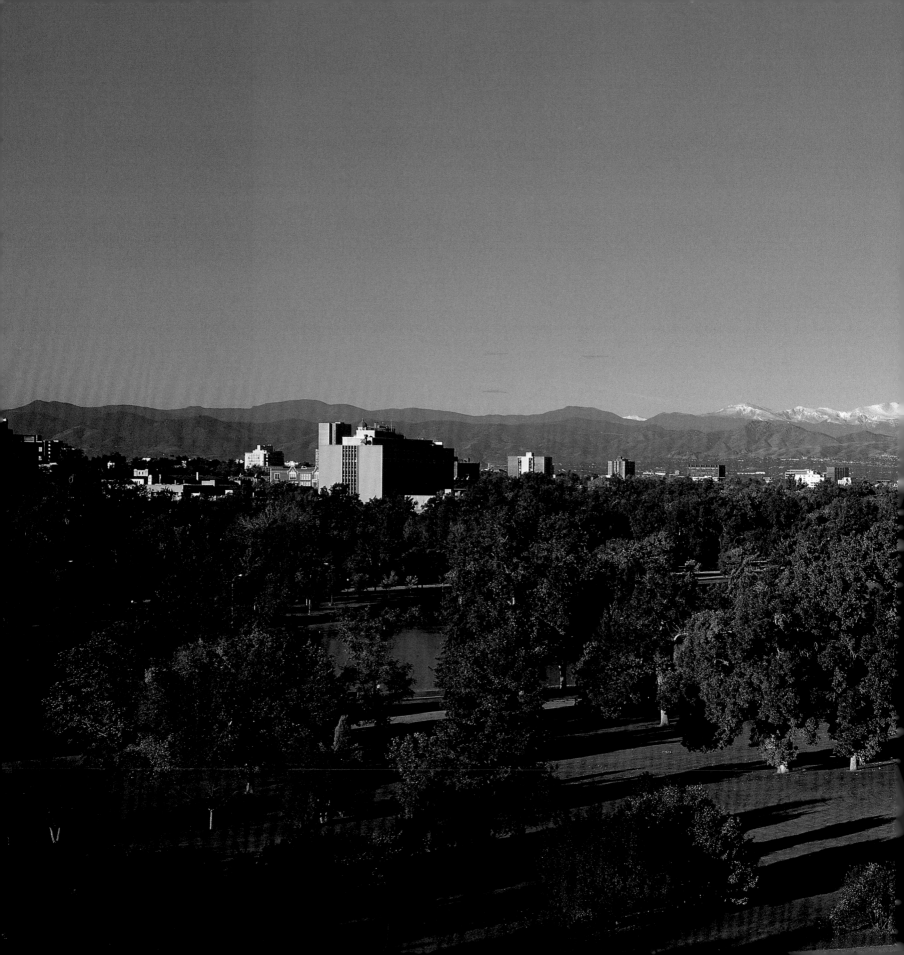

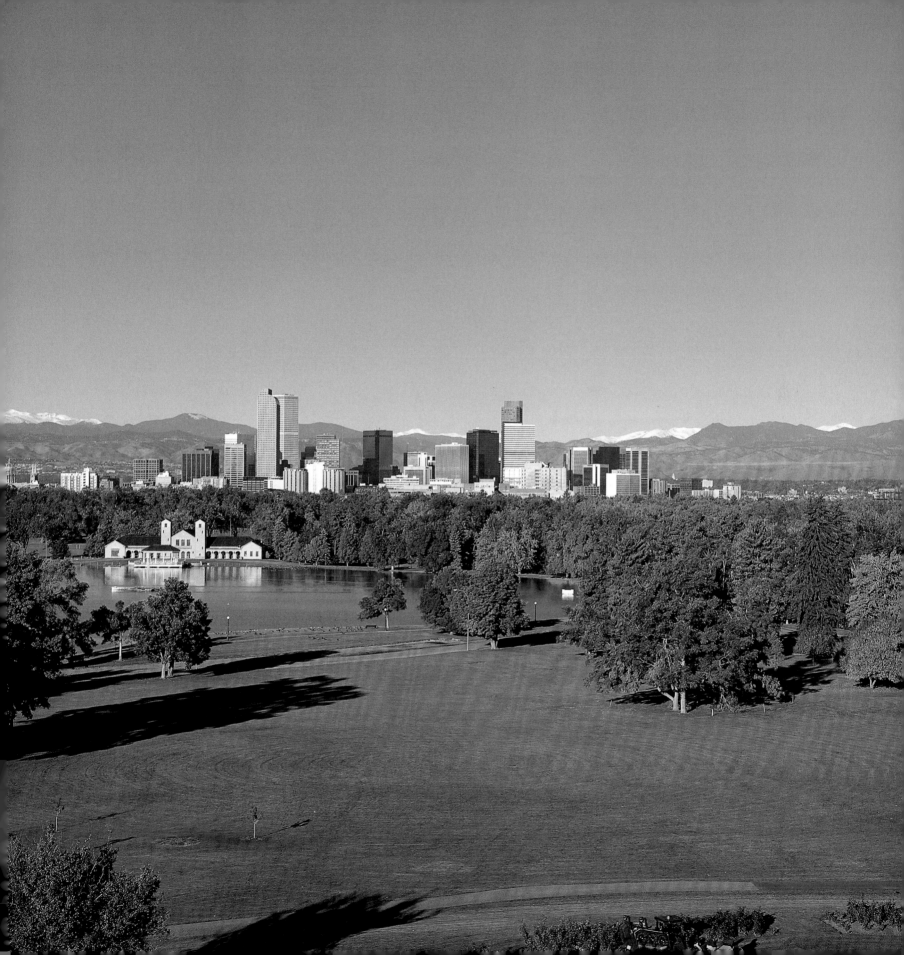

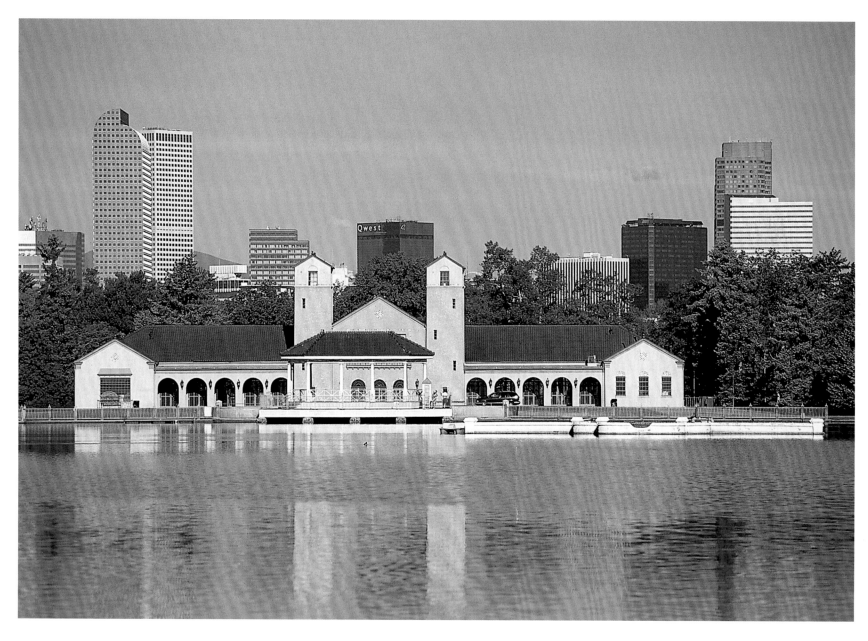

Summer evenings bring picnickers to the shores of Ferril Lake in City Park, where the sounds of live jazz bands drift from the park's pavilion. The 320-acre green space, the largest in Denver, also offers jogging, cycling, golf, tennis, baseball, and football facilities.

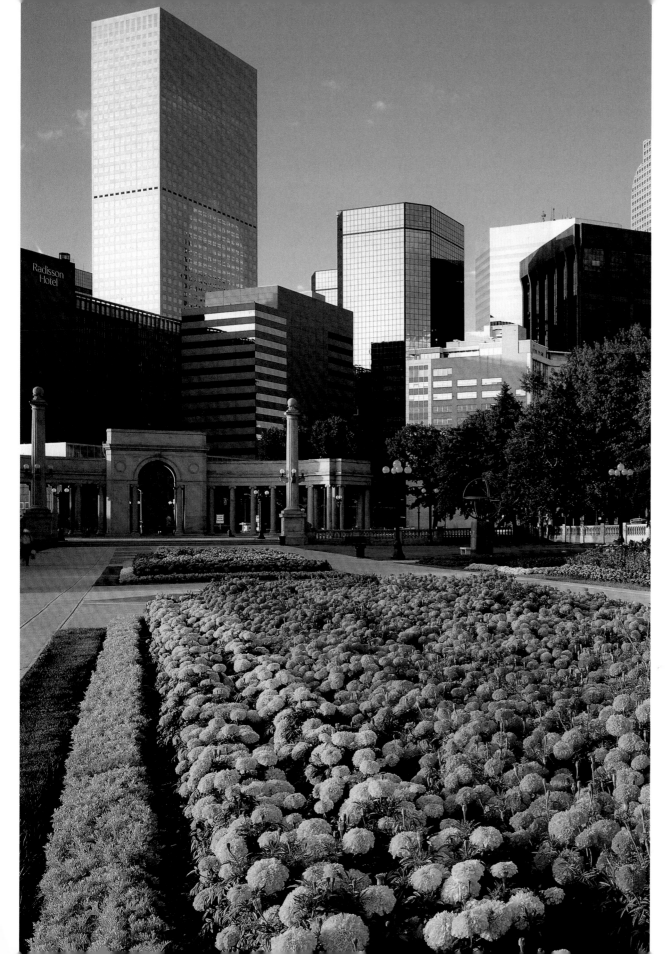

As the largest city in a 600-mile radius, Denver is a booming commercial center. But the city's downtown core offers much more than business. A pedestrian mall through the heart of the city leads visitors to museums, restaurants, shopping plazas, a performing arts complex, a convention center, and more.

OVERLEAF
Denver enjoys 300 days of sunshine each year (more than even Miami Beach) and offers recreational opportunities in 205 city parks. Another 20,000 acres of parkland await on the surrounding mountain slopes.

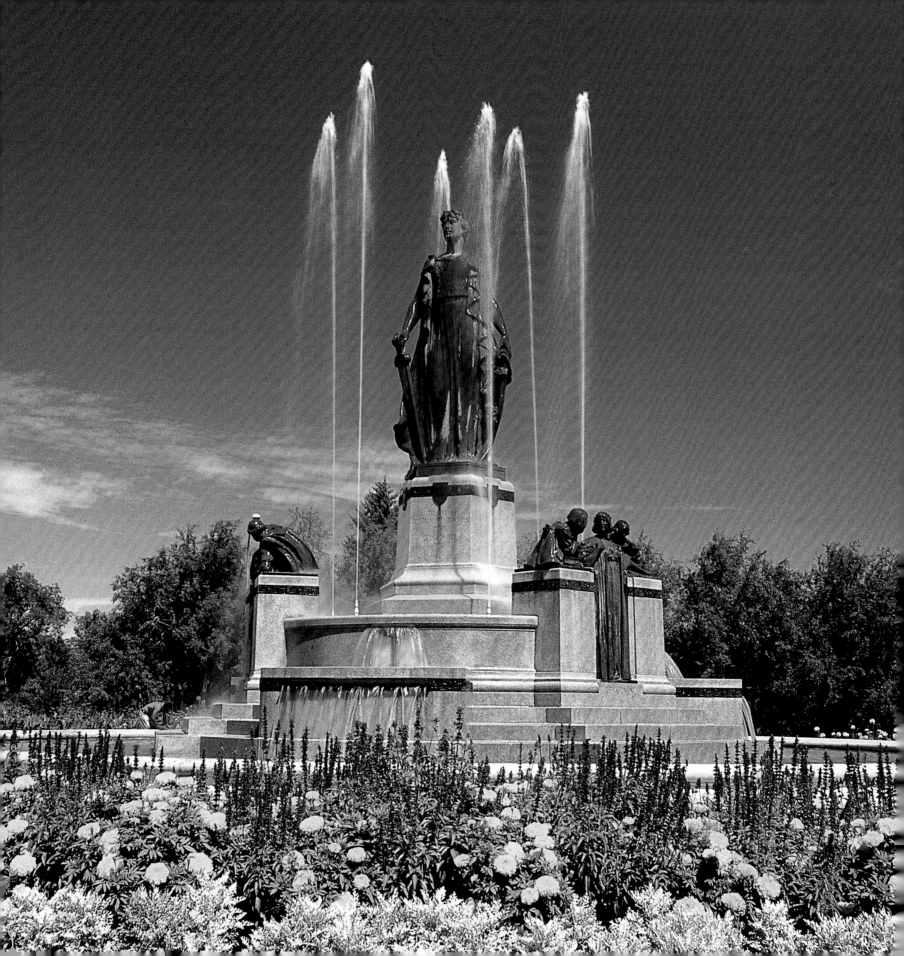

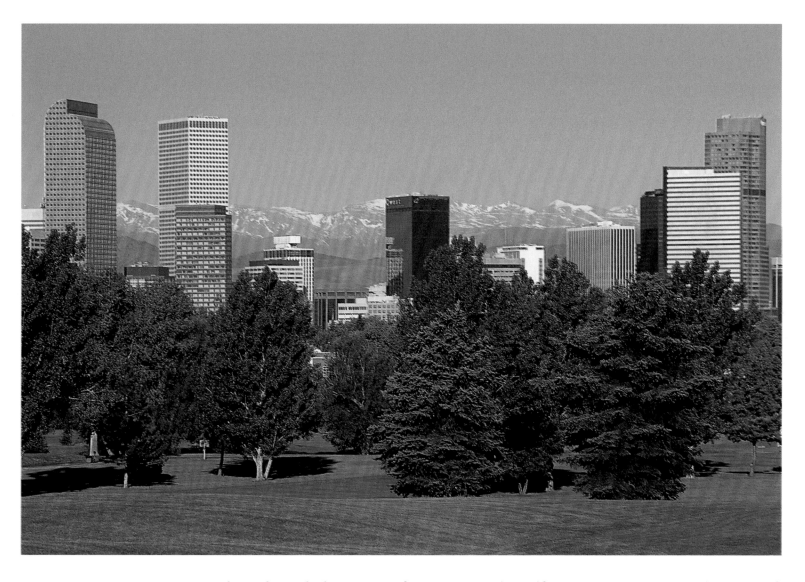

The urban skyline views from City Park Golf Course give way to glimpses of the Rocky Mountains behind. The 18-hole course, only minutes from downtown, was developed in 1912 after the City Park Dairy Farm offered its land to the city.

This City Park fountain was created by Chicago-based sculptor Laredo Taft. Joseph Thatcher, chairman of the Denver National Bank, bought the fountain for the city of Denver in 1917. The three bronze sculptures symbolize loyalty, learning, and love.

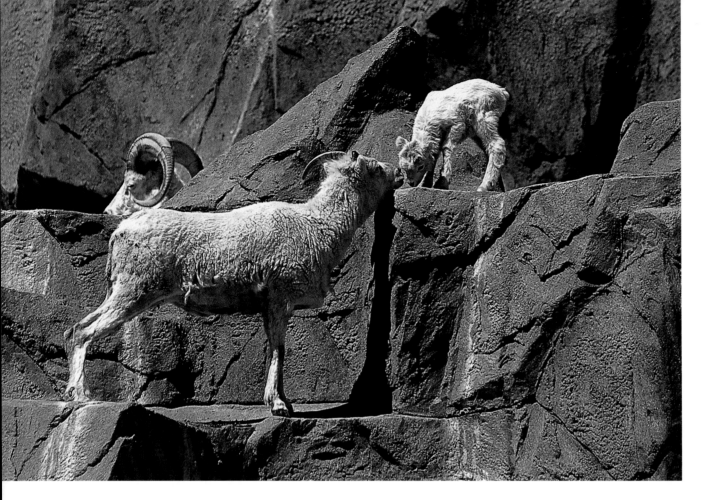

These Dall sheep are among thousands of animals at the Denver Zoo in City Park. The zoo educates visitors about threatened species, from the creatures of the Rocky Mountains, corralled by urban sprawl, to those of the African savanna, endangered by poaching and population growth.

The Prehistoric Journey exhibit at the Denver Museum of Nature and Science whisks sightseers from the sea-based life of 3.5 billion years ago to the age of the dinosaurs. Other museum displays explore ancient Egypt, the mysteries of Colorado's gems and minerals, and the lives of North America's bear species.

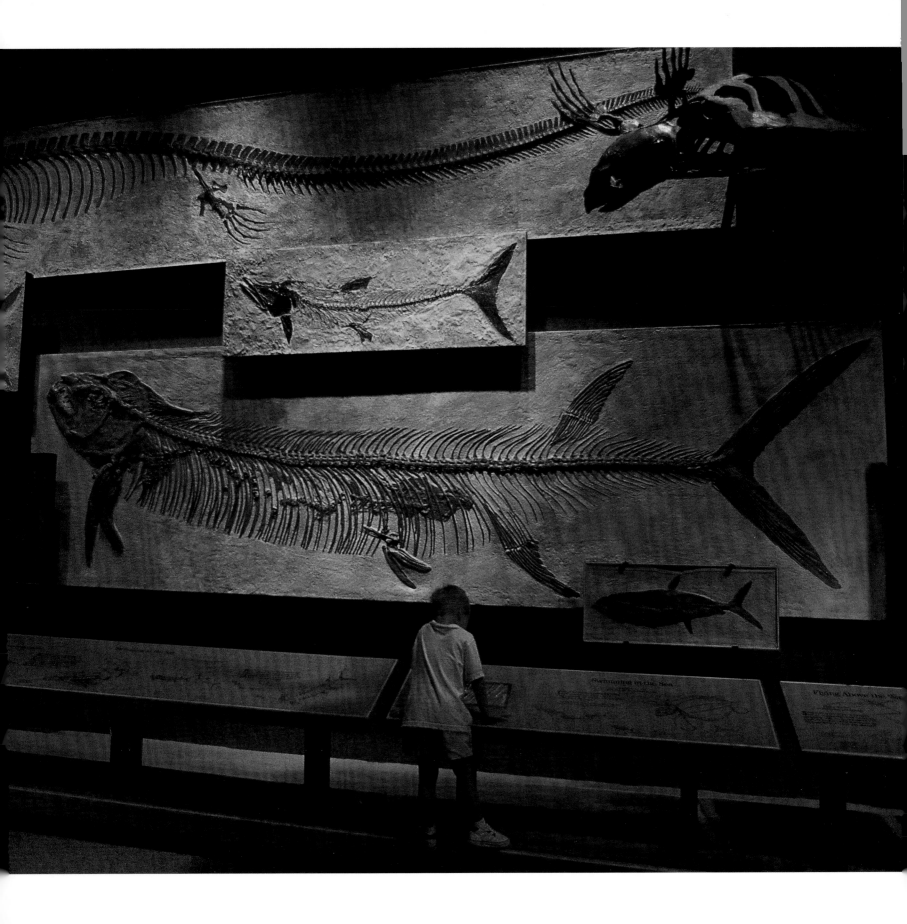

Denver is a gold rush boomtown turned cosmopolitan center. In the early 1900s, the city's wealthy were already transforming streets of saloons and gambling halls to tree-lined promenades. The Queen City of the Plains continues to grow—the population more than doubled between 1960 and 2000.

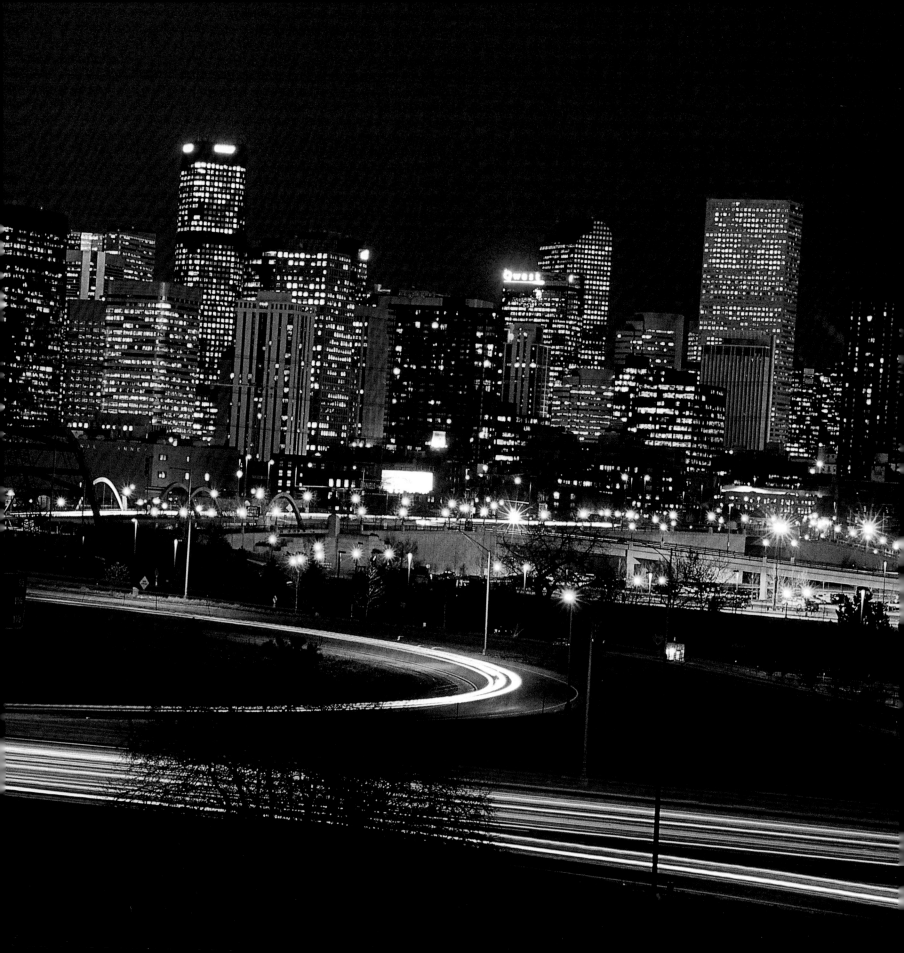

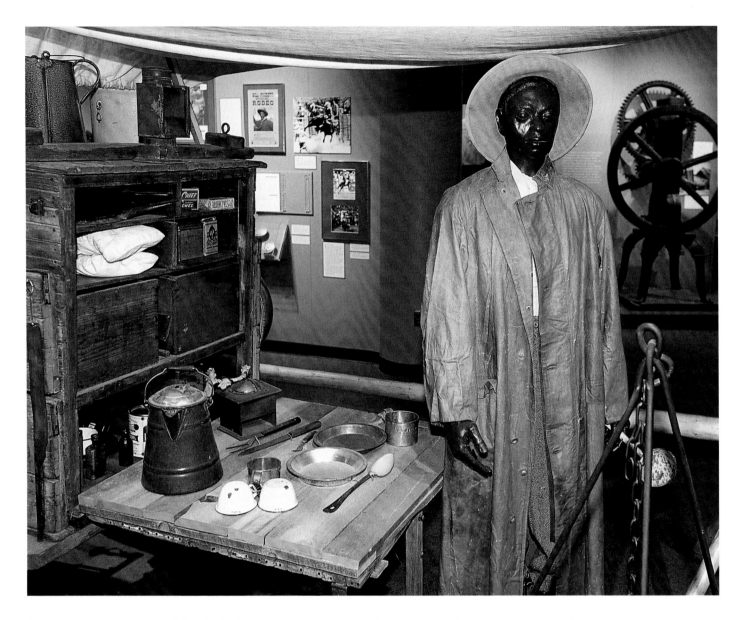

From fur traders and buffalo hunters to wagon drivers and homesteaders, the Colorado History Museum provides a close look at the lives of the state's early residents. One of the museum's intriguing displays tells the story of the 9,000 African-American cowboys who once traveled the rangelands of the west.

An Irish celebration gets a Wild West twist at Denver's St. Patrick's Day Parade. Marching bands, traditional dancers, and shamrock-clad floats are joined by stagecoaches and rodeo riders. This is the largest of the city's annual parades.

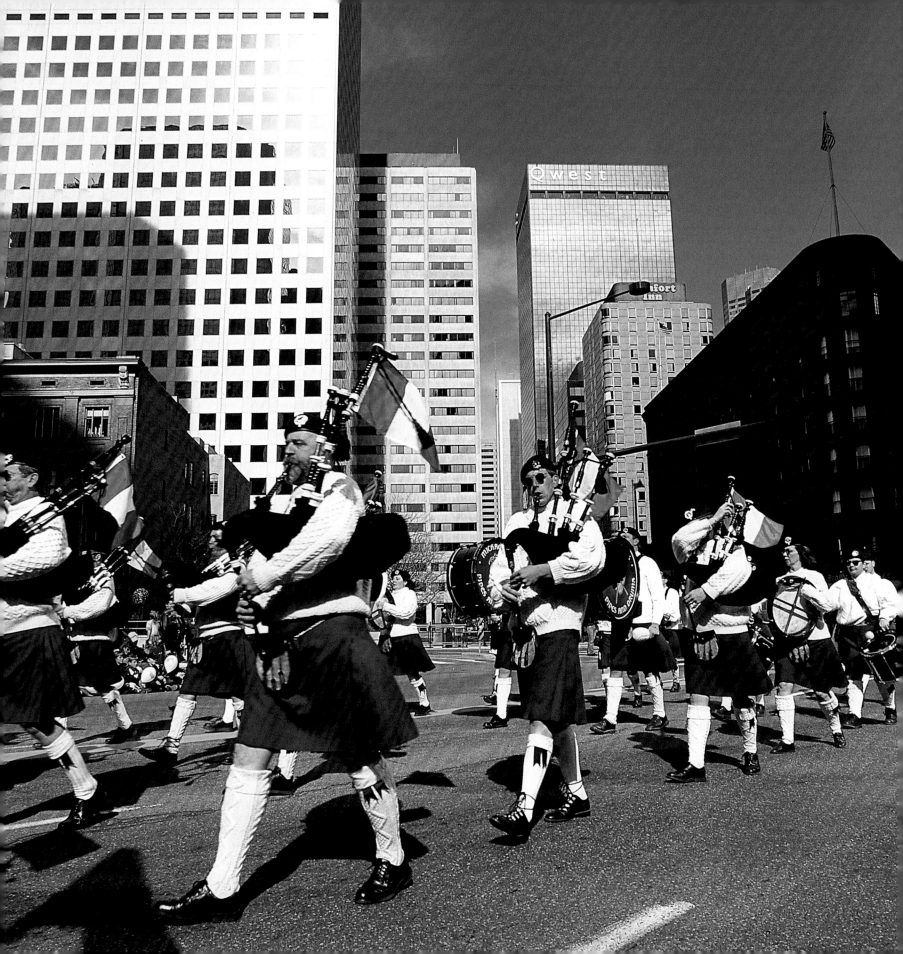

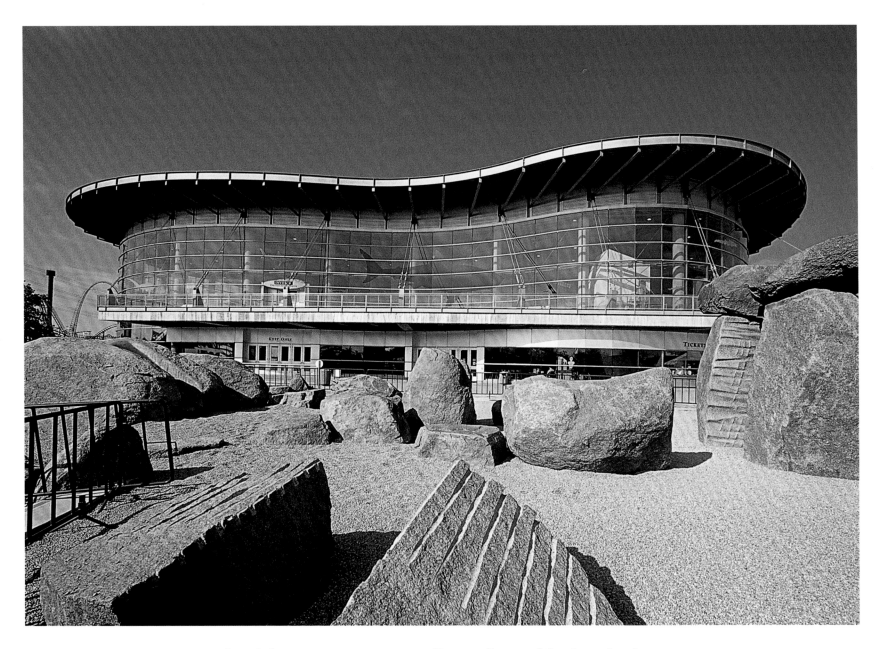

With exhibits containing one million gallons of fresh and salt water, Ocean Journey Aquarium recreates the Colorado River, the Sea of Cortez, an Indonesian river, and the Pacific Ocean's depths. Cofounders Bill Fleming and Judy Petersen-Fleming raised $93 million in the 1990s to build the facility and recreate ecosystems with sights, smells, and sounds.

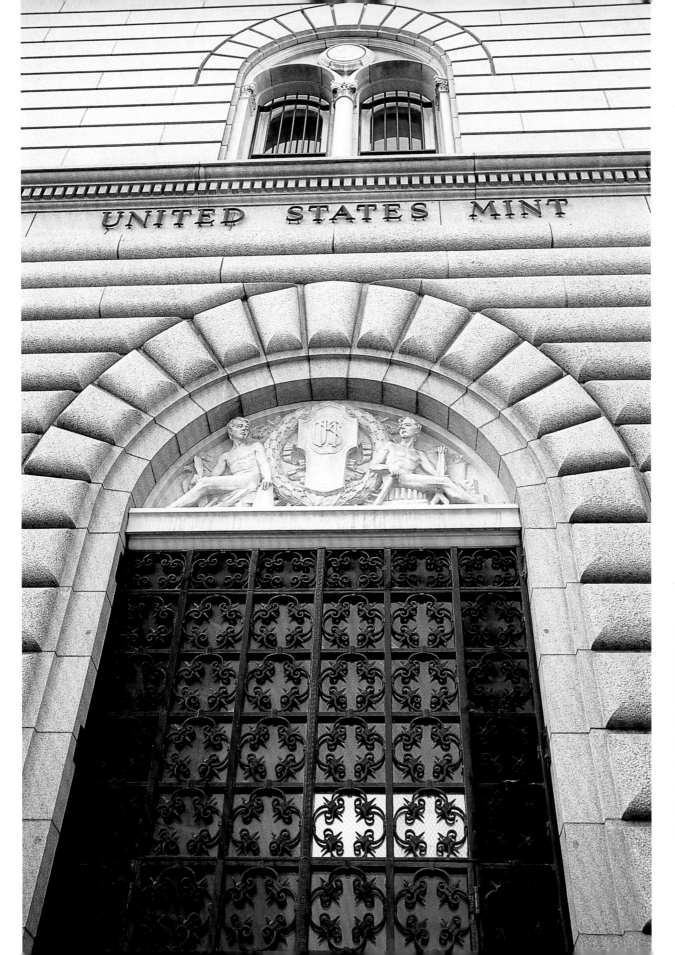

When it opened in 1863, the United States Mint in Denver melted the region's gold nuggets into bars. Today, the facility creates about 10 billion coins each year, including commemorative sets and coins for regular circulation. It is one of two U.S. Mint facilities that offers tours.

Cling wrap and lassos, flaming swords and unicycles—props at the Downtown Denver International Buskerfest range from the mundane to the downright dangerous. Each June, the city is inundated by hundreds of jugglers, acrobats, mimes, musicians, and magicians, all competing for audiences and passing their hats through the crowds.

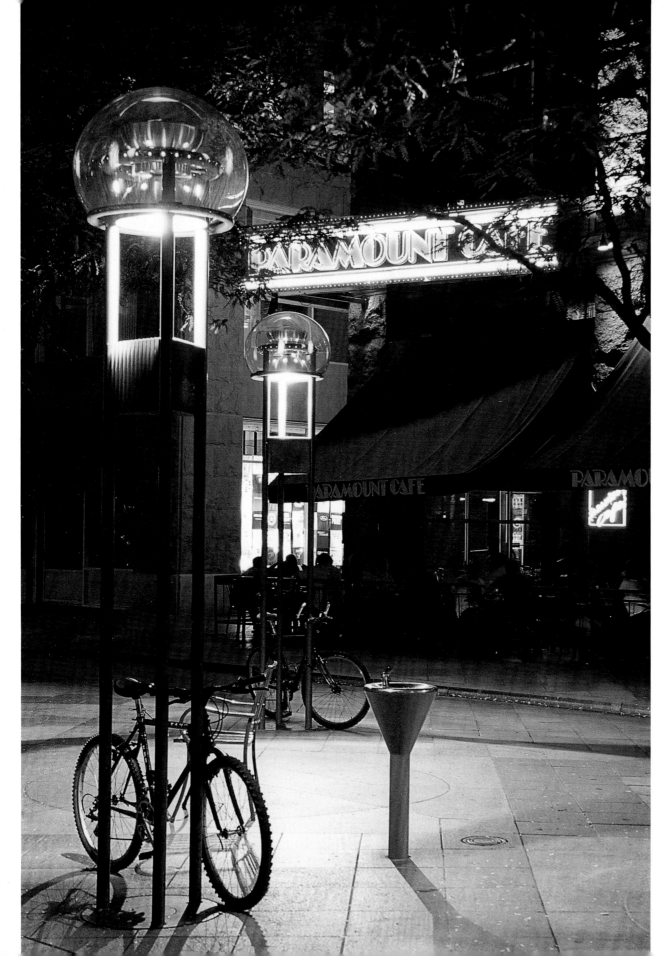

The people-watching mecca of downtown Denver, the Paramount Café provides outdoor dining and an ever-changing selection of craft beer. The café stands along the 16th Street Mall, a mile-long pedestrian thoroughfare linking the downtown financial center with the LoDo neighborhood.

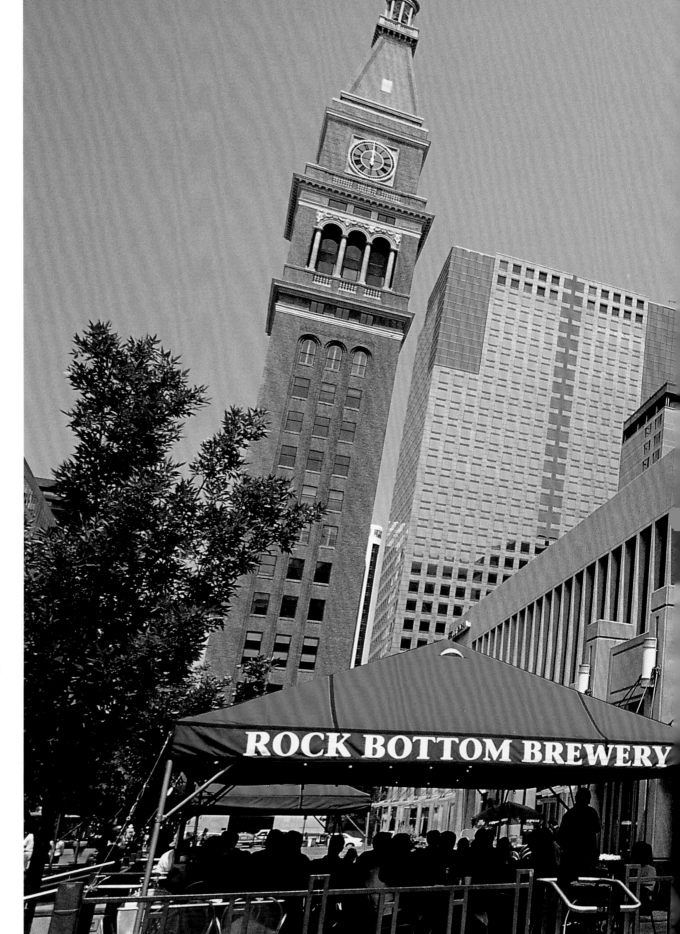

Visitors will find up to 50 unique beers at Denver's microbreweries and brew pubs—varieties available nowhere else. Colorado is home to the Coors and Anheuser-Busch breweries and produces more beer than any other state in the nation.

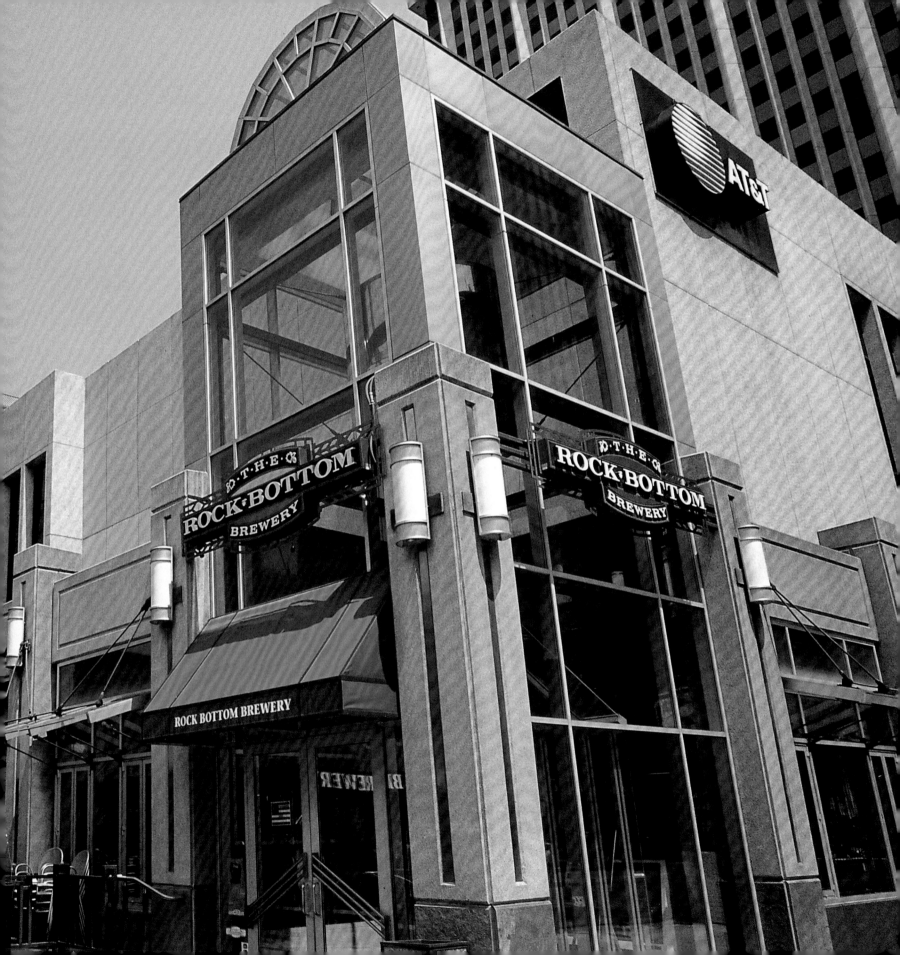

Served by free shuttles every 90 seconds, the 16th Street Mall is an eclectic mix of people and products. Tourists, buskers, and sidewalk chess players mix in front of designer boutiques, souvenir shops, and fast-food outlets.

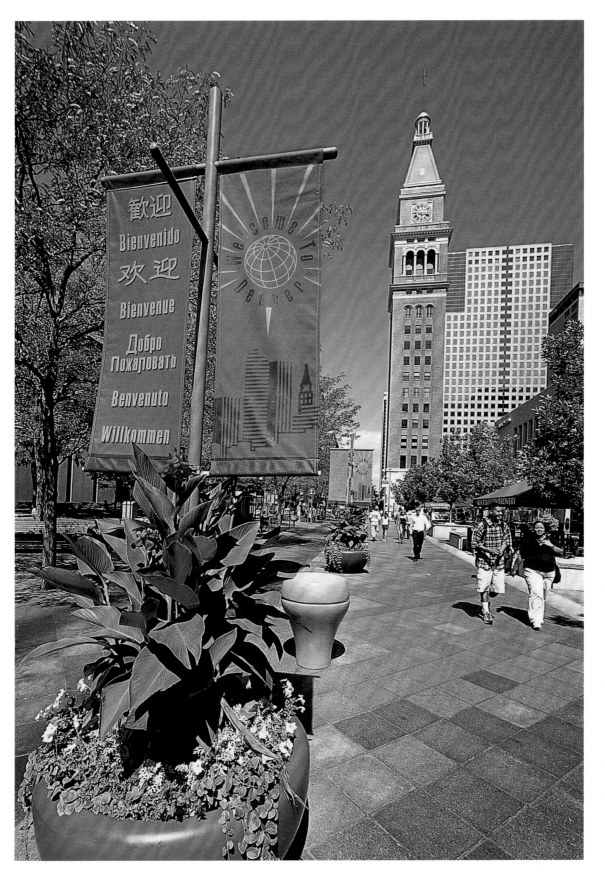

For the downtown business crowd, the 16th Street Mall is the perfect place to escape the shadows of the skyscrapers and enjoy the summer sun. The street is adorned with 25,000 flowers and bordered by 200 locust and red oak trees.

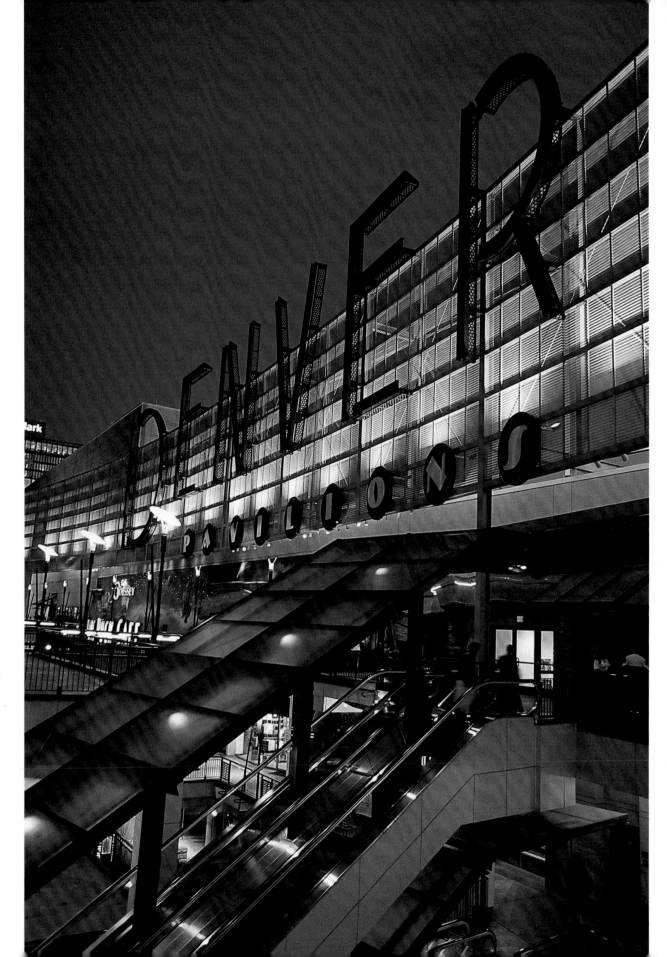

Stretching along two blocks of the 16th Street Mall, Denver Pavilions combines 50 retail stores with eateries, nightclubs, and a 15-screen cinema. The 350,000-square-foot complex also hosts free summer concerts, charity fundraisers, arts festivals, and children's events.

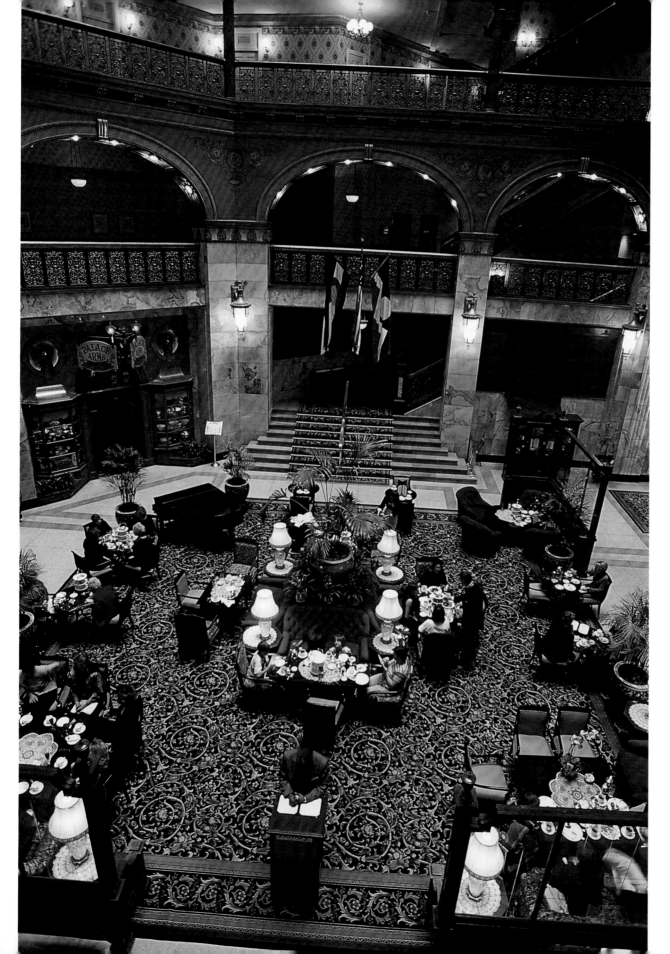

Denver architect Frank E. Edbrooke designed the Brown Palace Hotel as a triangular, 241-room building with a central atrium. Afternoon tea is a hotel tradition, served in the lobby with the strains of harp and piano music in the background.

OVERLEAF
Entrepreneur Henry C. Brown opened the Brown Palace Hotel in 1892. Since then the "oasis on the plains" has accommodated almost every American president, including President Dwight D. Eisenhower, who used it as his summer headquarters. Other distinguished guests have included Chinese revolutionary Dr. Sun Yat Sen, Queen Marie of Romania, and Russian president Boris Yeltsin.

43

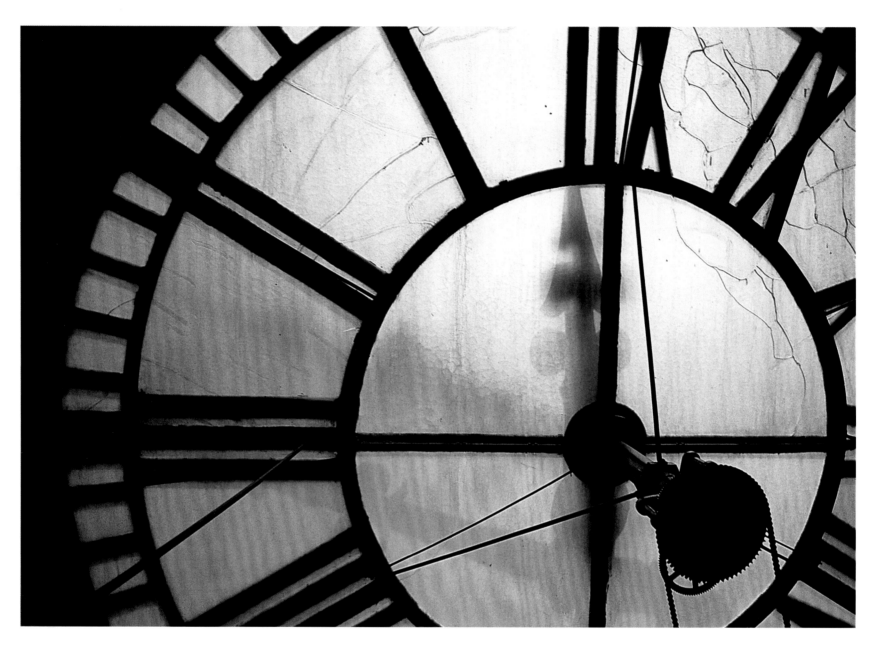

This translucent clock is one of four adorning the Renaissance Revival–style Daniels & Fisher Tower, built in 1910. Originally intended to house Daniels & Fisher Dry Goods, the 375-foot building outlived the department store and now houses offices and a small museum.

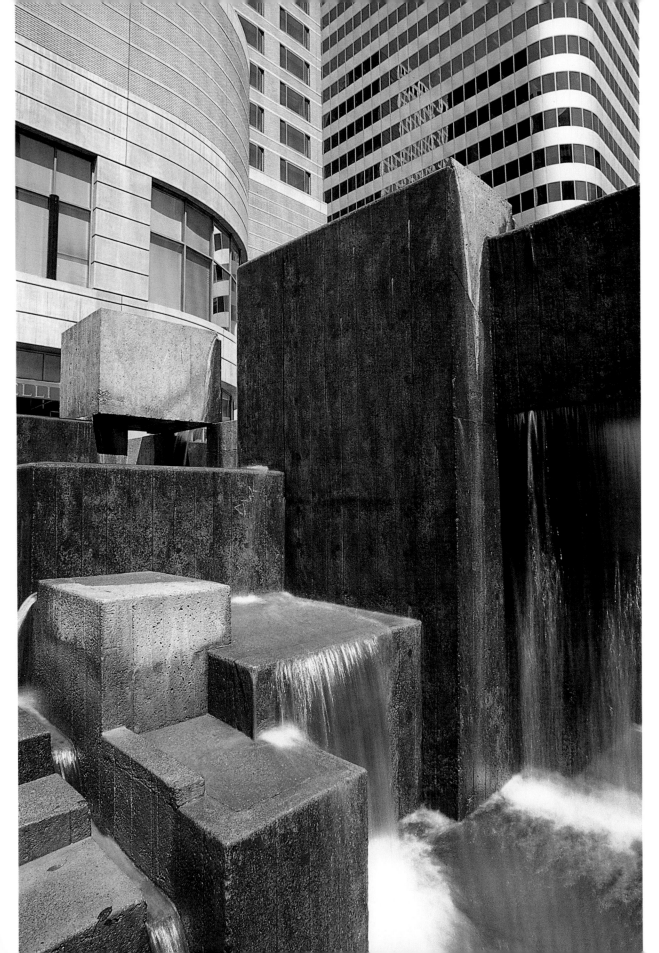

Created by renowned landscape architect Lawrence Halprin in the 1970s, Skyline Park extends for three blocks in downtown Denver. Designed to remind viewers of the rugged Colorado landscape, this park fountain reflects Halprin's belief that the city environment should appeal to all the senses.

47

Boutiques, art galleries, outdoor cafés, and even horse-drawn carriage rides draw shoppers and sightseers to Writer Square. Cobblestone walks, and gas street lamps add to the square's historic appeal.

48

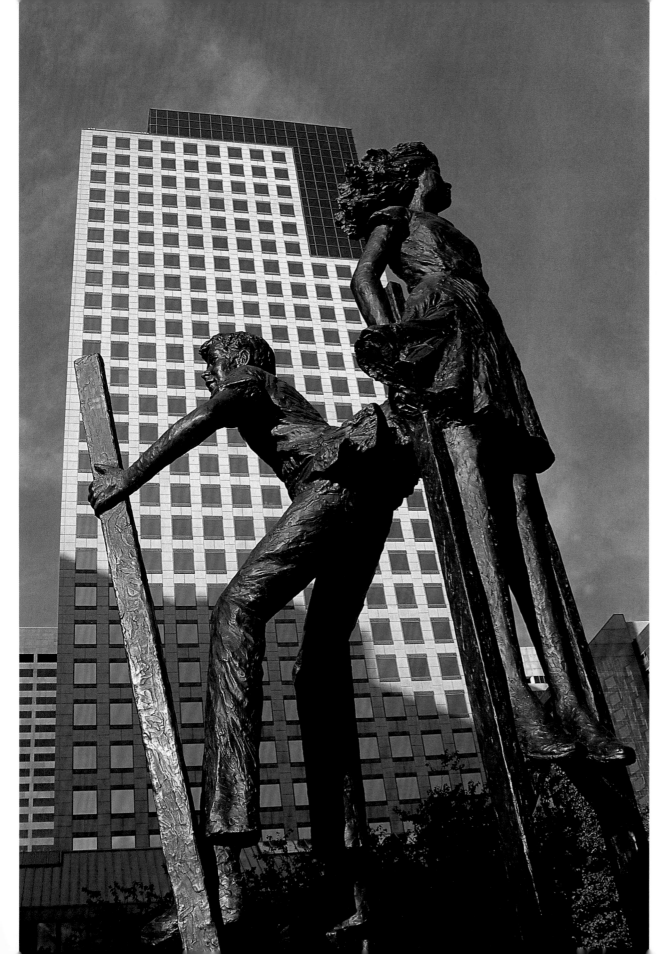

*Stilt Walkers,* a bronze casting by Dennis Smith, adds a whimsical air to Writer Square. Along with privately funded pieces such as this one, many of Denver's streets and parks showcase art sponsored under the city's highly successful public art program.

49

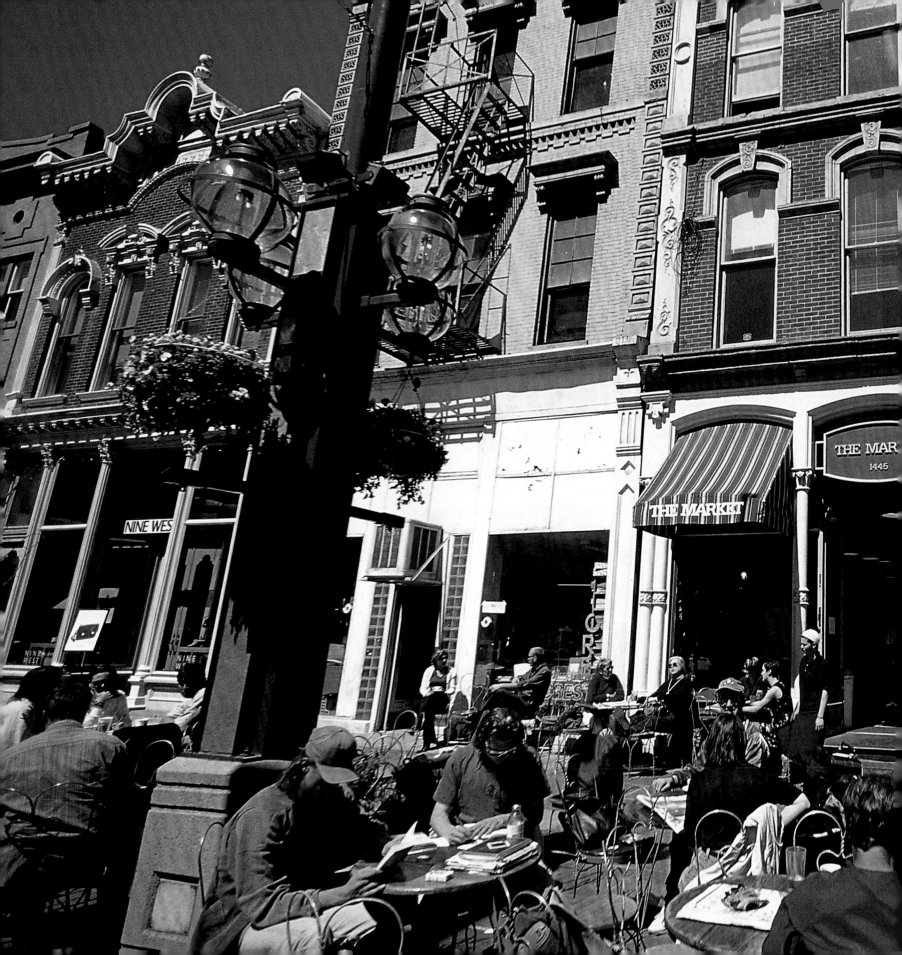

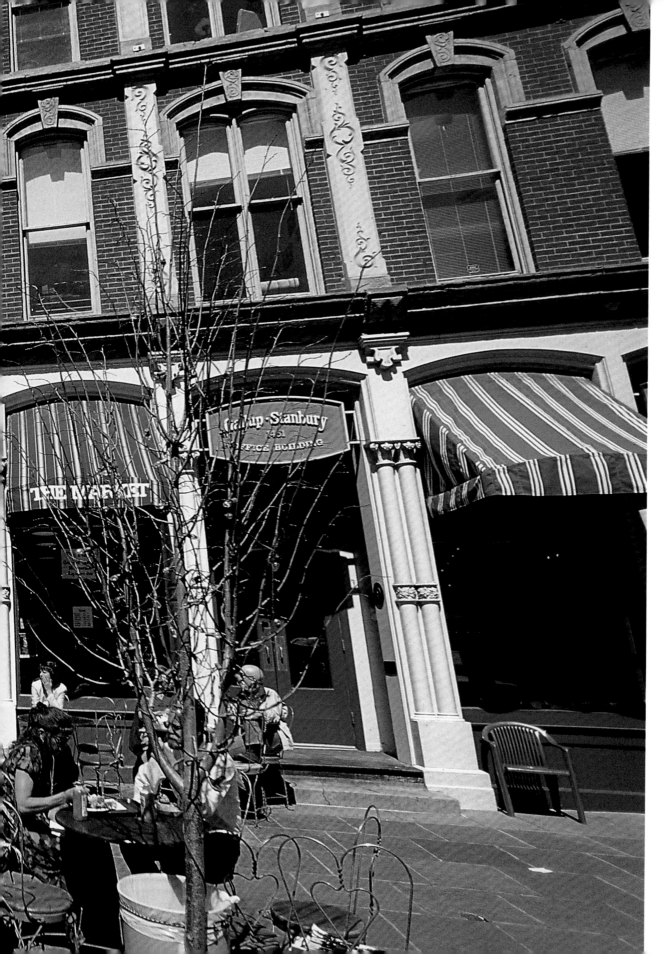

Larimer Square is named for one of the first white settlers to arrive in this area, General William H. Larimer, Jr. The square stands where the original town of Denver was born, including the region's first bank, dry goods store, post office, and theater. Today the square remains a hub of activity, lined with restaurants and shops.

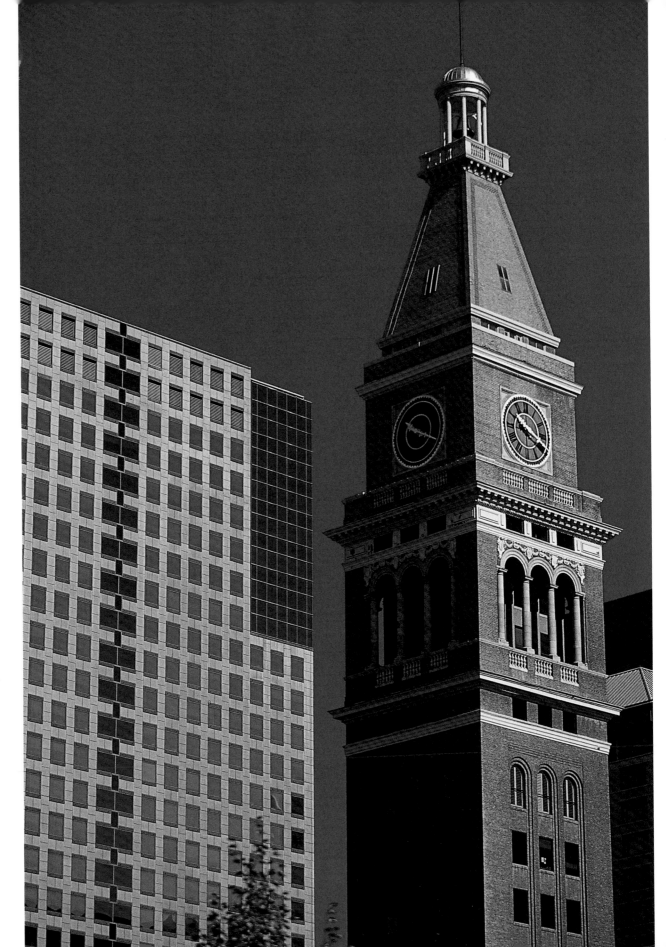

One of the first highrise residential towers in downtown, the 42-story Brooks Tower helped revitalize the city core in the 1960s. The downtown population is growing once again as new condominium developments and the district's entertainment venues draw a young and active demographic.

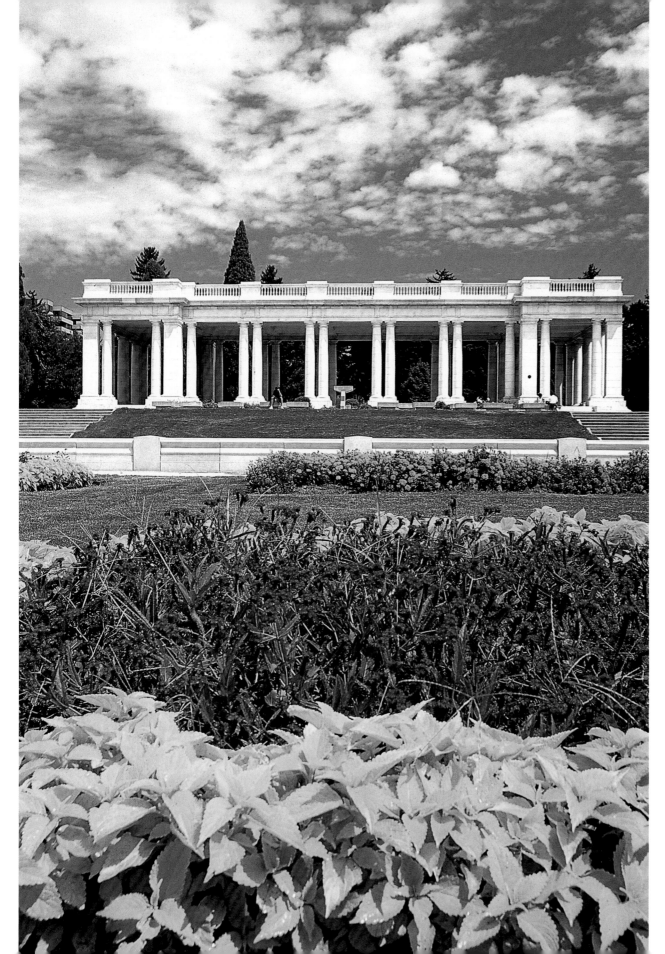

Cheesman Park was the site of one of Denver's first cemeteries. The remains were moved in the 1890s, and the park now includes a playground, a jogging path, and summer concert facilities. The central pavilion was donated by the family of Walter Cheesman, a local pioneer who made his fortune as president of the Denver Union Water Company.

53

The Denver Center for the Performing Arts hosts a constantly changing lineup of local performances and touring productions from Broadway and beyond. The center is also home to the National Theatre Conservatory, a three-year acting program developed in partnership with the American National Theatre and Academy.

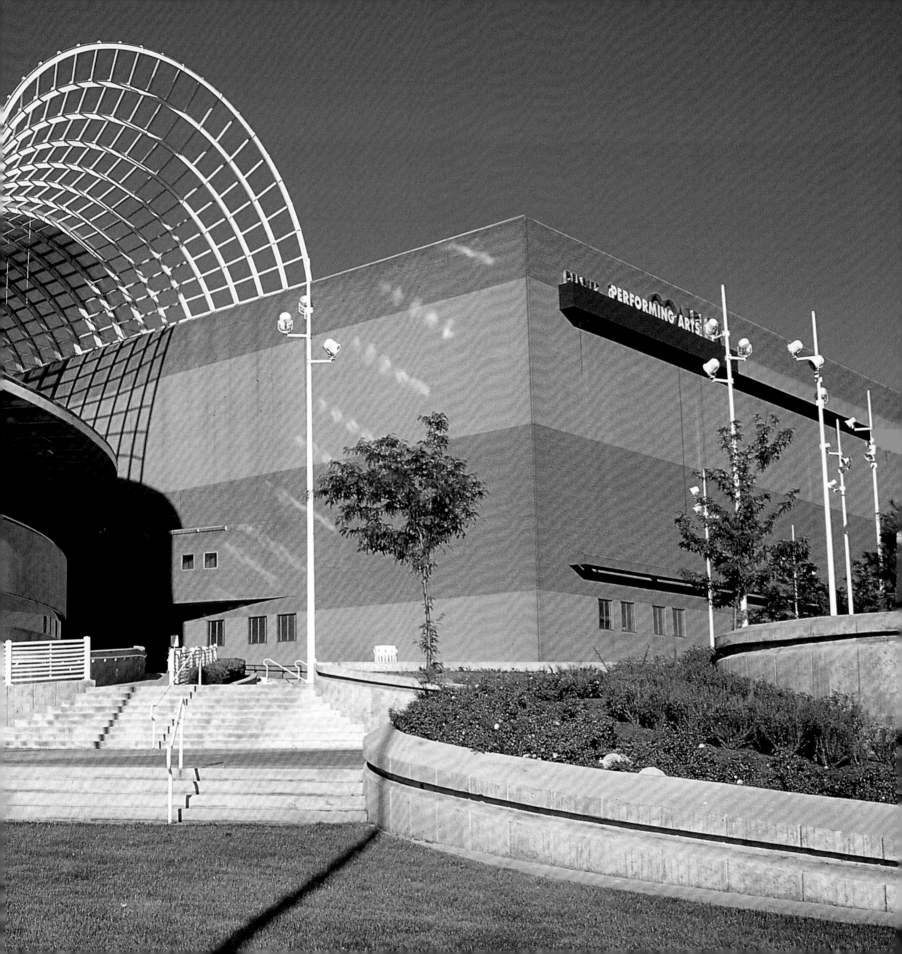

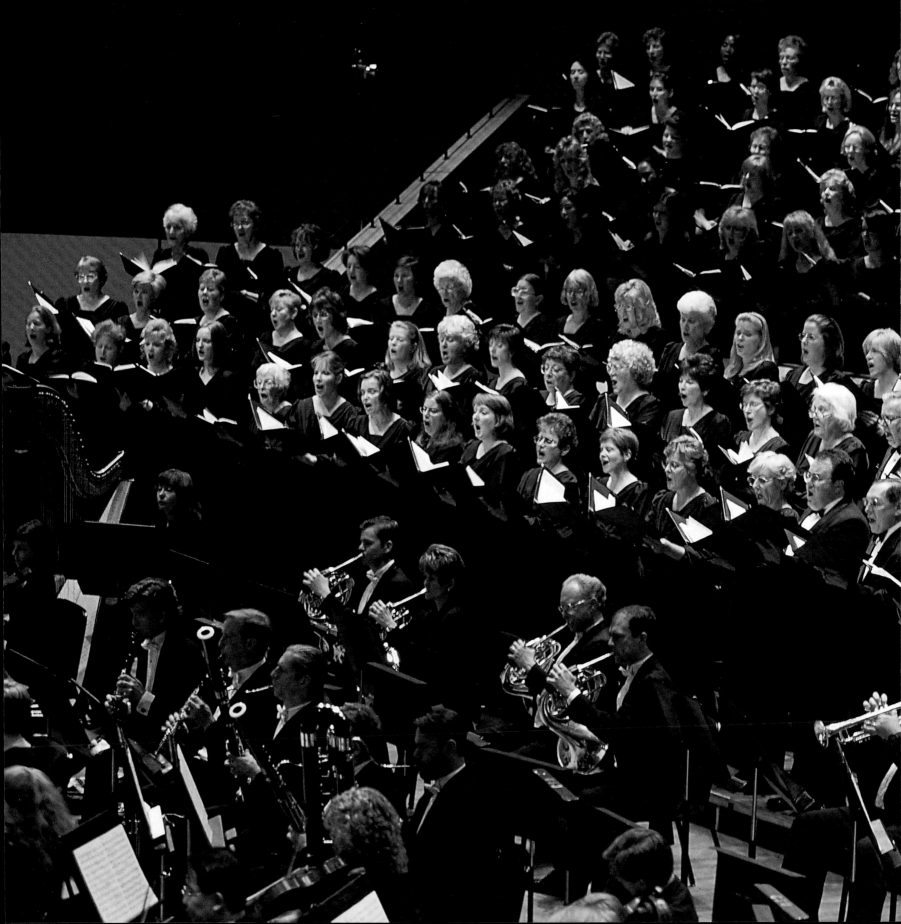

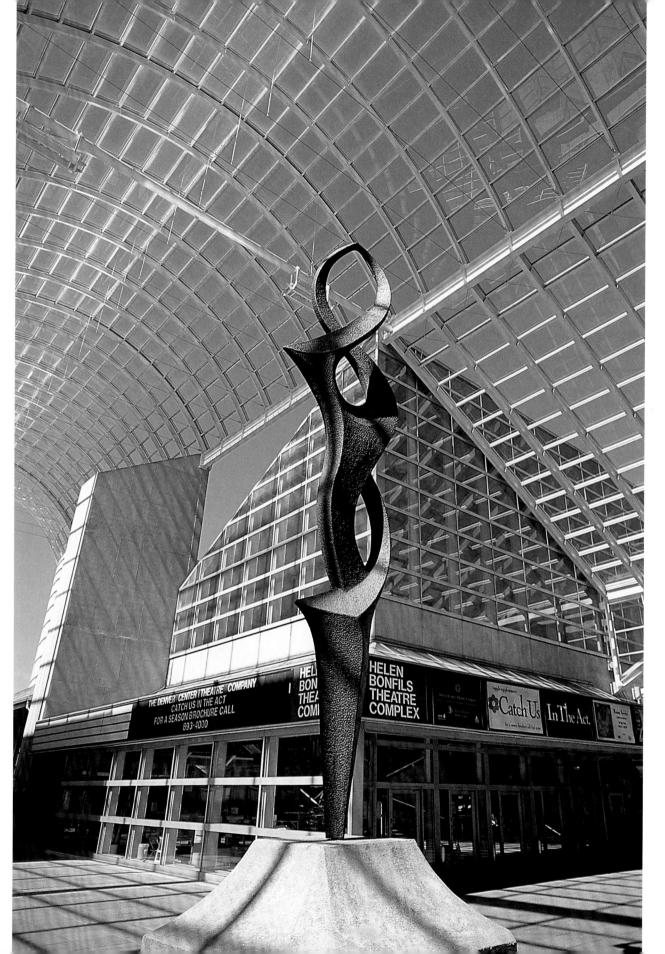

Encompassing four downtown blocks, the Denver Center for the Performing Arts boasts 9,200 seats in eight theaters. The center's unique design uses modern architecture to link several historic structures. The first theaters were built or renovated in the 1970s, and the most recent additions were completed in 1998.

FACING PAGE
The Colorado Symphony plays at Boettcher Hall at the Denver Center for the Performing Arts. Performing more than 100 concerts, the symphony attracts 250,000 music lovers each year.

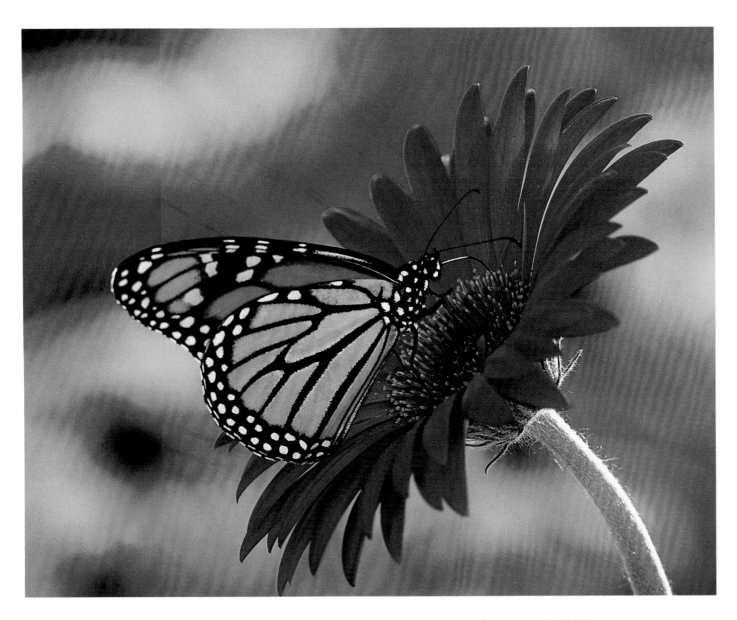

A monarch butterfly finds refuge within Denver Botanic Gardens. Each fall, monarchs west of the Continental Divide migrate to California. Those east of the Rocky Mountains journey south to Mexico.

Even in winter, the Boettcher Memorial Conservatory at Denver Botanic Gardens hosts a hot, humid world of exotic plants. The conservatory is named for Charles Boettcher, a German immigrant who made his fortune in Colorado industry. Before his death, he established a charitable foundation to fund Colorado-based enterprises.

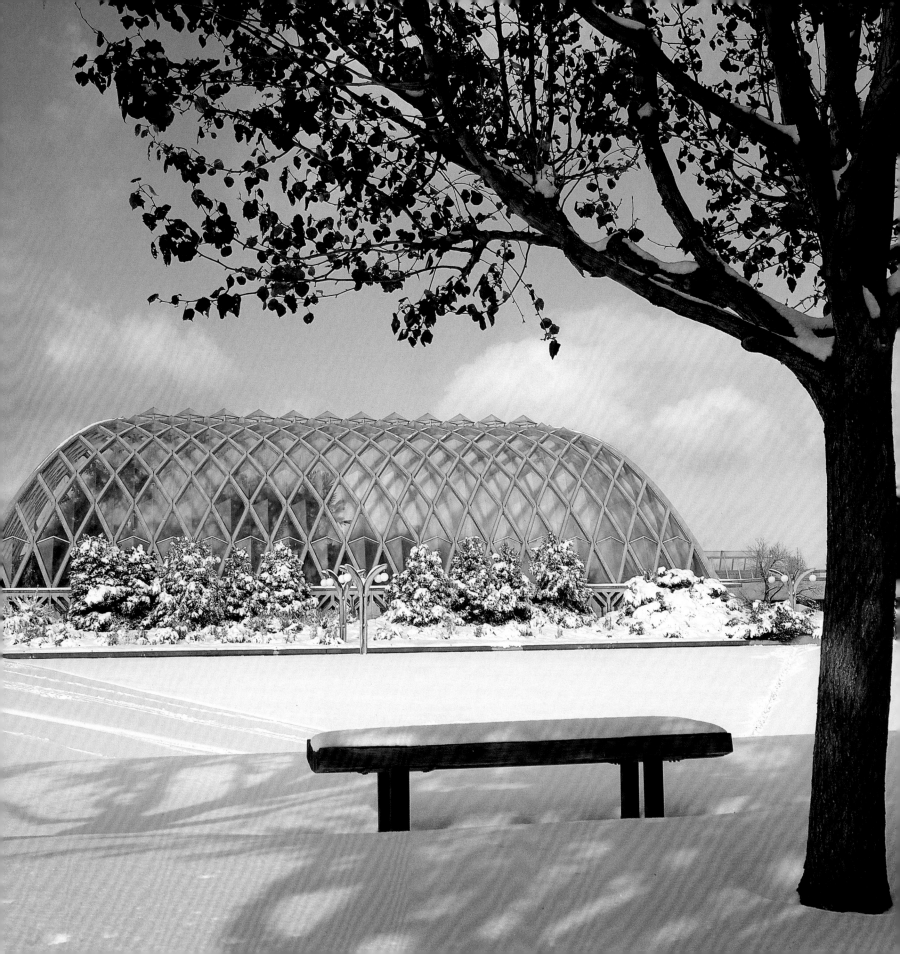

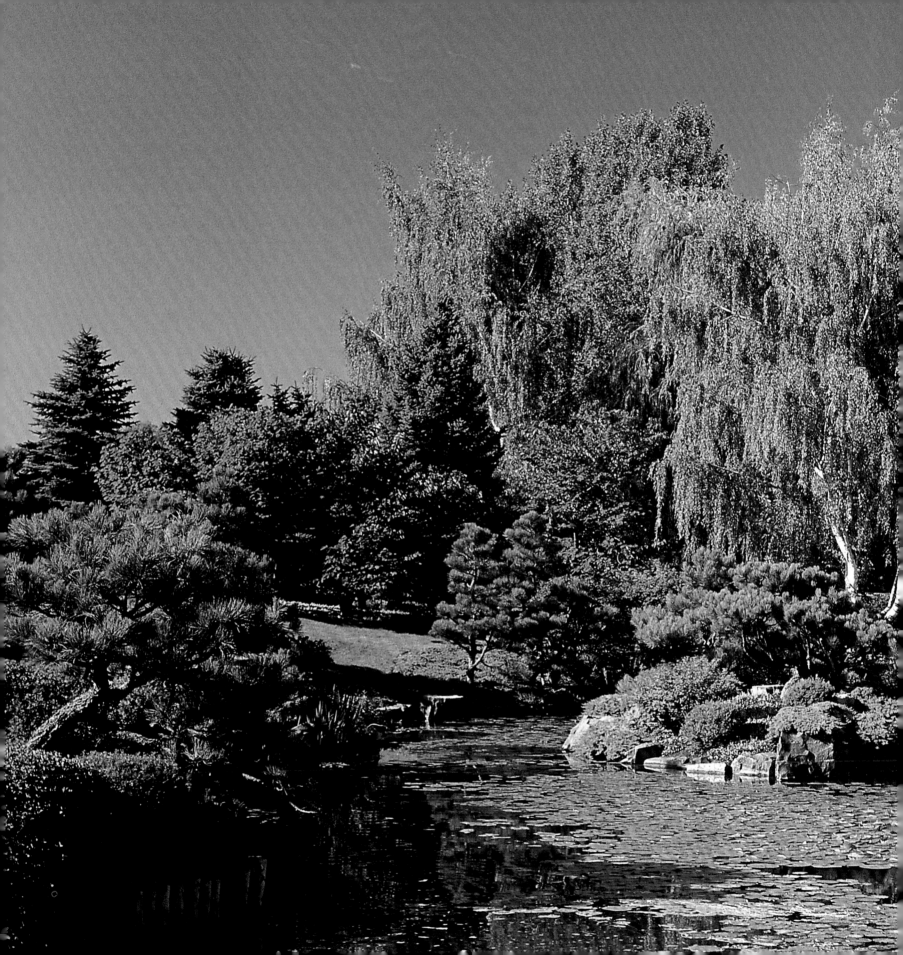

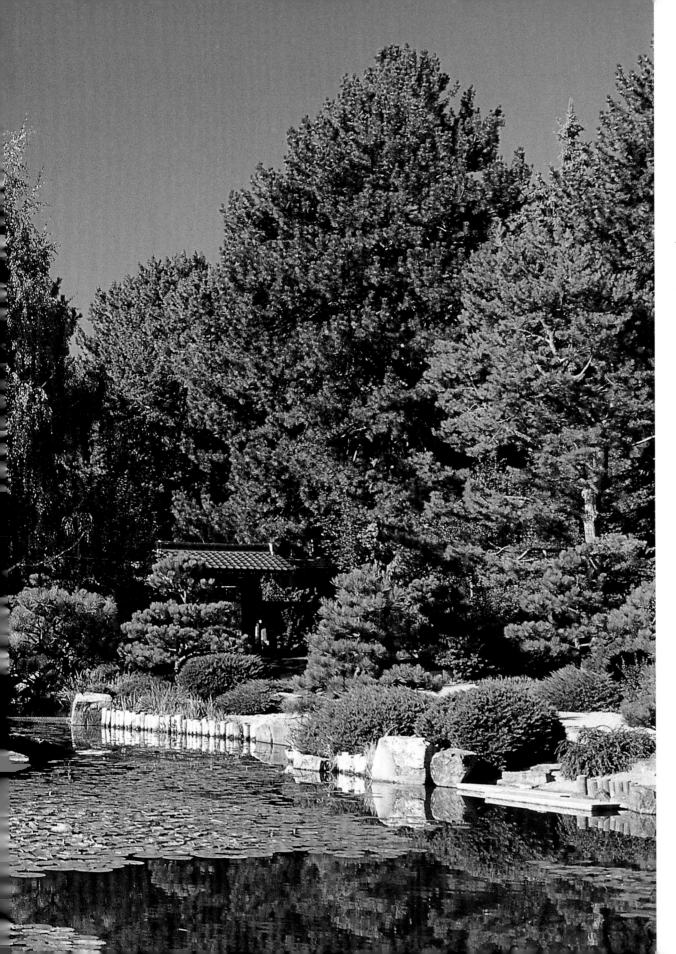

Just two miles from downtown, Denver Botanic Gardens is a 23-acre natural oasis. Plantings like the Dryland Mesa and Western Panoramas exhibit the climate and ecosystems of Colorado, while other areas, such as this Japanese garden, display diverse plant life from around the world.

OVERLEAF
More than 300,000 lights adorn the trees and shrubs of Denver Botanic Gardens each December during the Blossoms of Light celebration. Nightly entertainment, warm drinks, and winter plant displays transform the gardens into a snowy wonderland for the hundreds of families who visit each year.

61

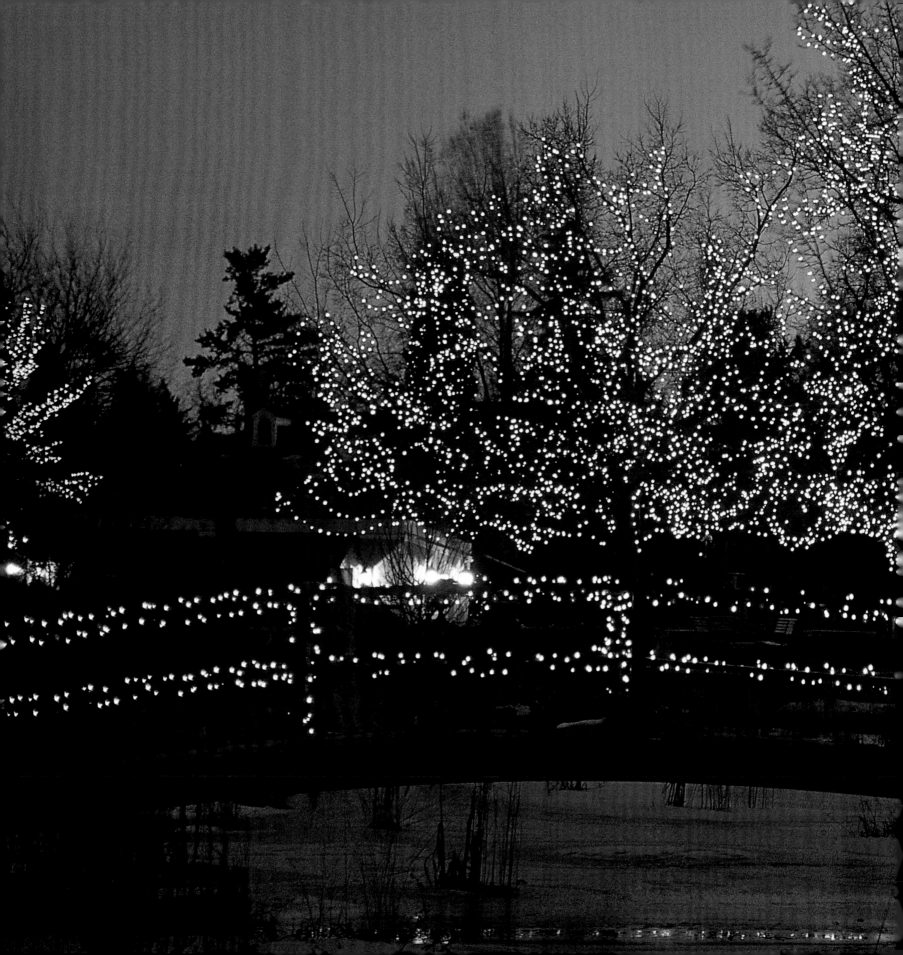

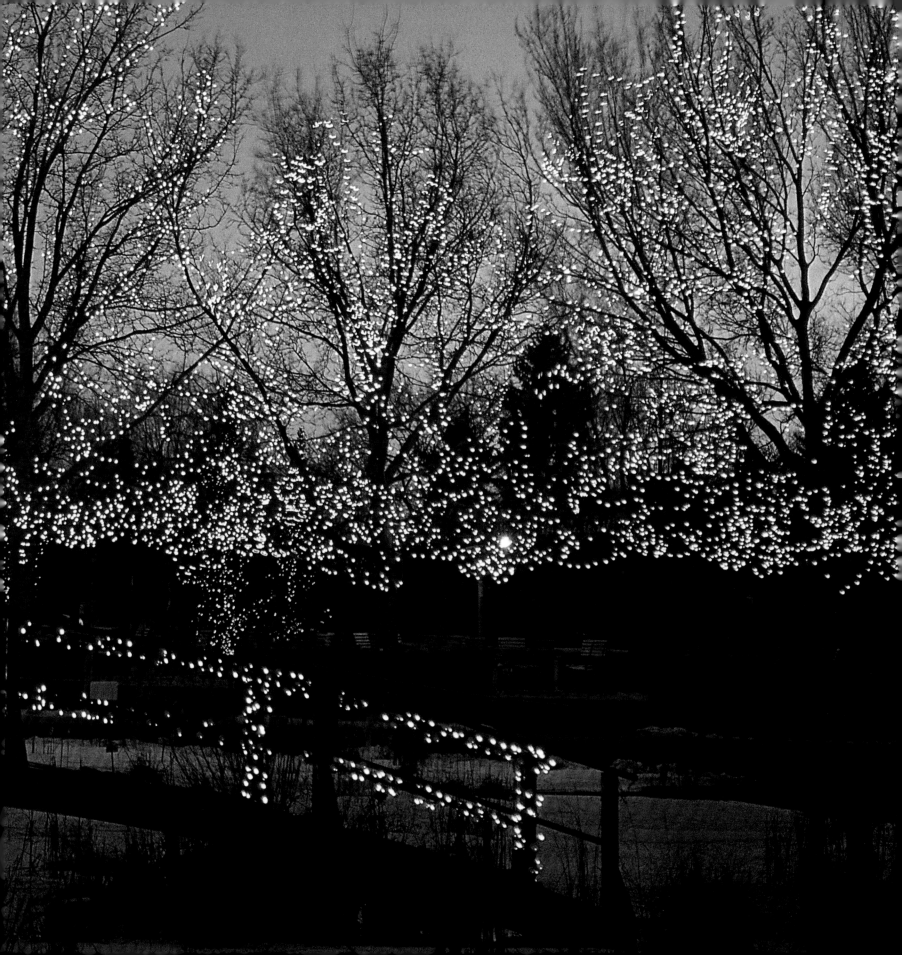

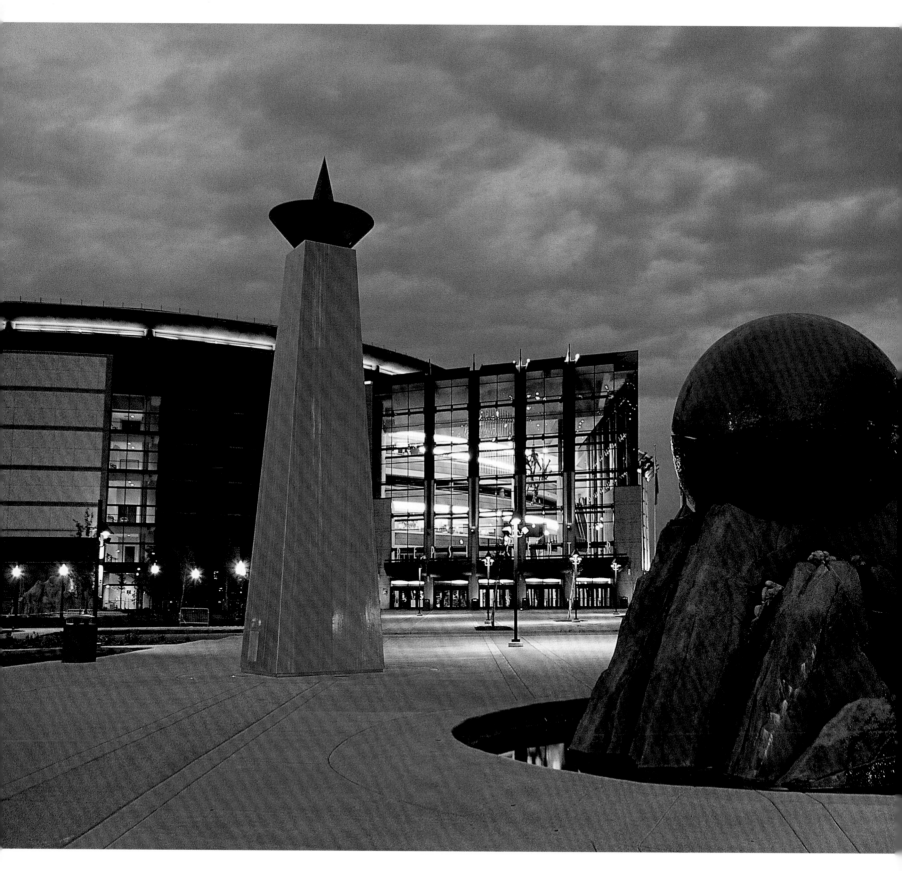

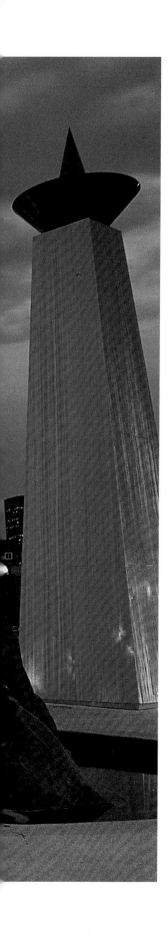

For more than 10 years, the LoDo Music Festival has brought bands from around the world to Denver's arts and entertainment district each summer. The festival began as one stage in historic Union Station; it now includes almost 40 acts over two days, in venues throughout the neighborhood.

It's not unusual to find the Pepsi Center packed with more than 18,000 screaming fans. This is the home of the NHL's Colorado Avalanche and the NBA's Denver Nuggets. The 675,000-square-foot facility also hosts football games, indoor lacrosse, music concerts, and special events.

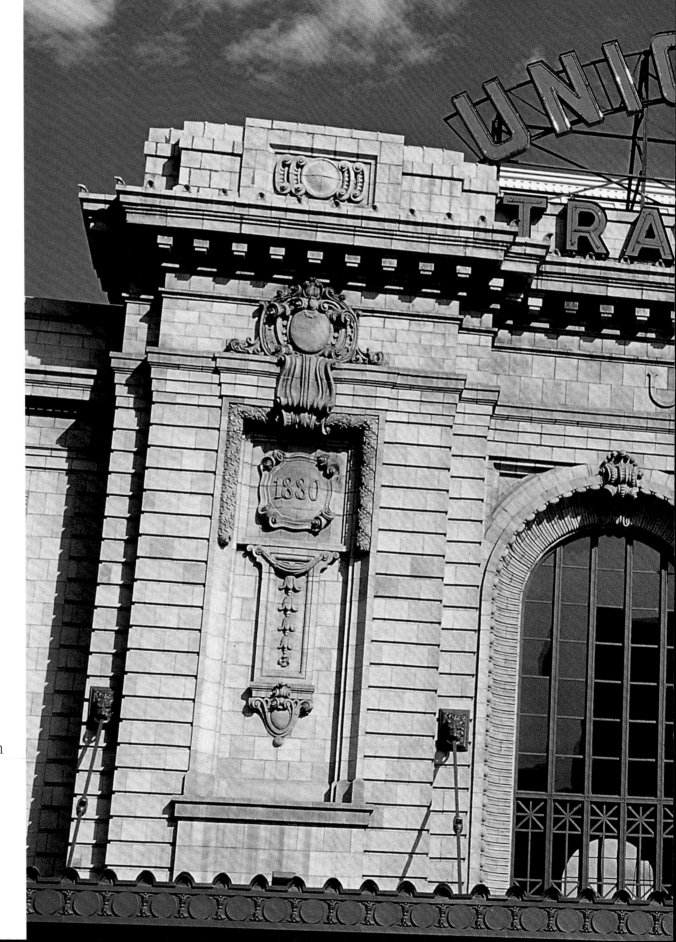

Denver's Union Station was built in 1914, replacing an earlier depot destroyed by fire. In the 1920s and 1930s, more than 80 trains a day stopped here. The station served more travelers than the local airport until 1958.

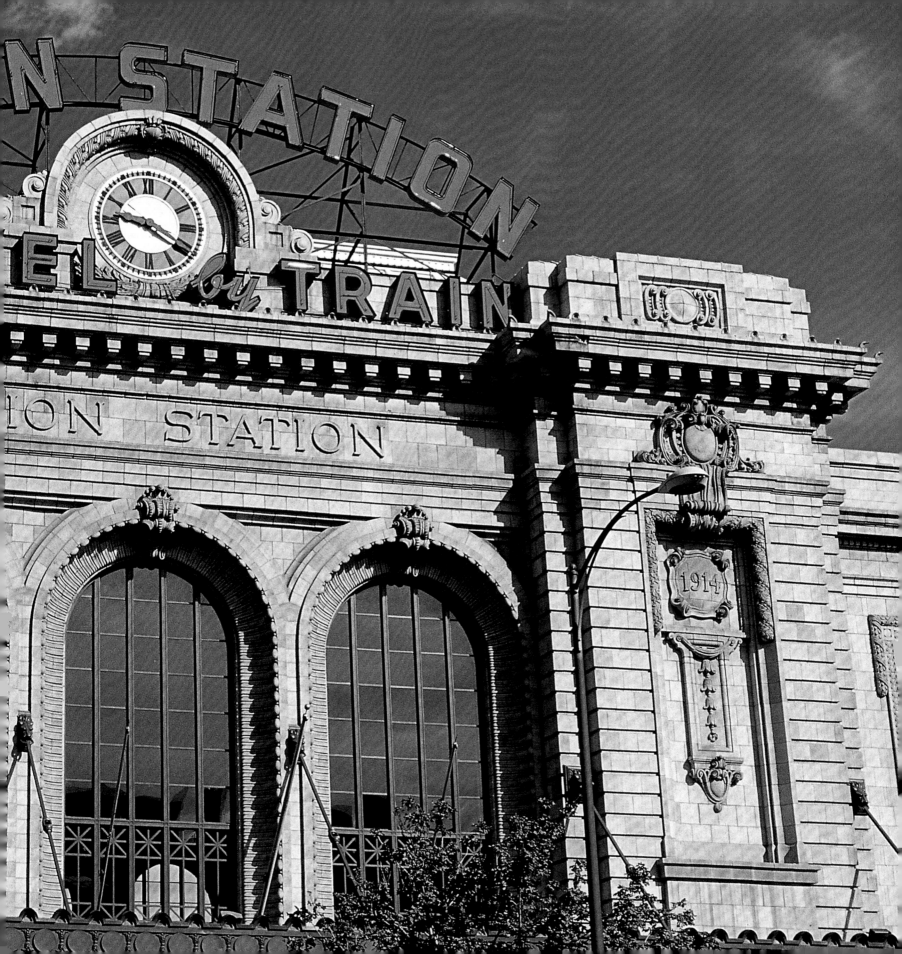

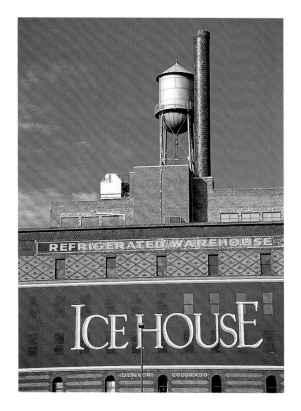

LoDo, or Lower Downtown, combines some of the city's most vibrant entertainment spots with industrial buildings, art galleries, and brew pubs. The Icehouse, now converted into modern lofts, is one of many structures dating from a century ago that were built of red brick due to a shortage of timber and an abundance of clay.

Opened in 1891 at the height of the silver rush, LoDo's Oxford Hotel housed a barber shop, a telegraph office, stables, and a saloon. The hotel was restored in the 1980s using architect Frank Edbrooke's original drawings. Today's guests find 80 rooms furnished in fine antiques.

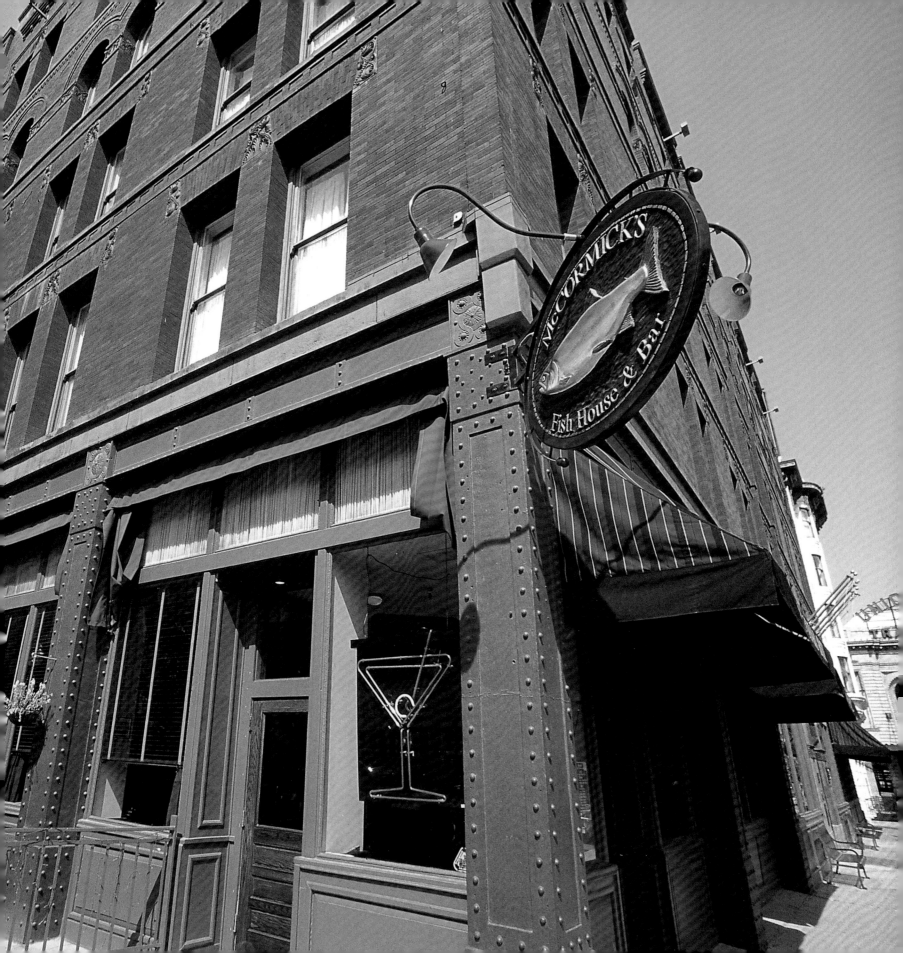

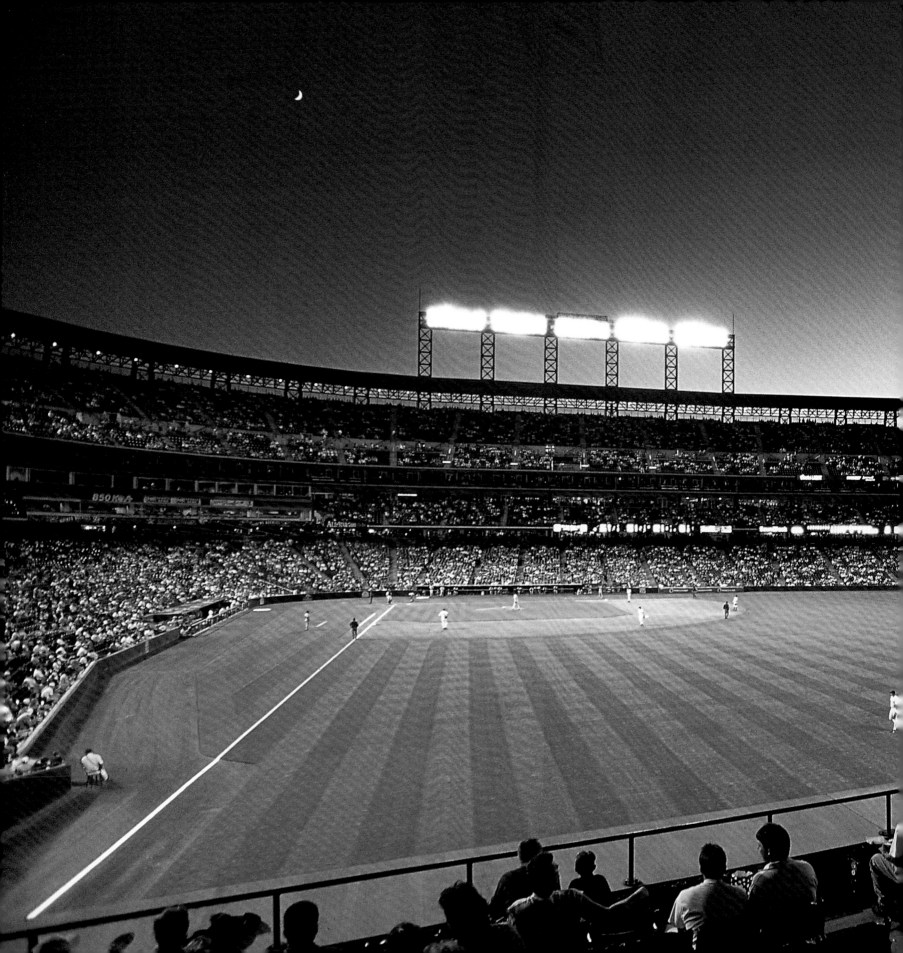

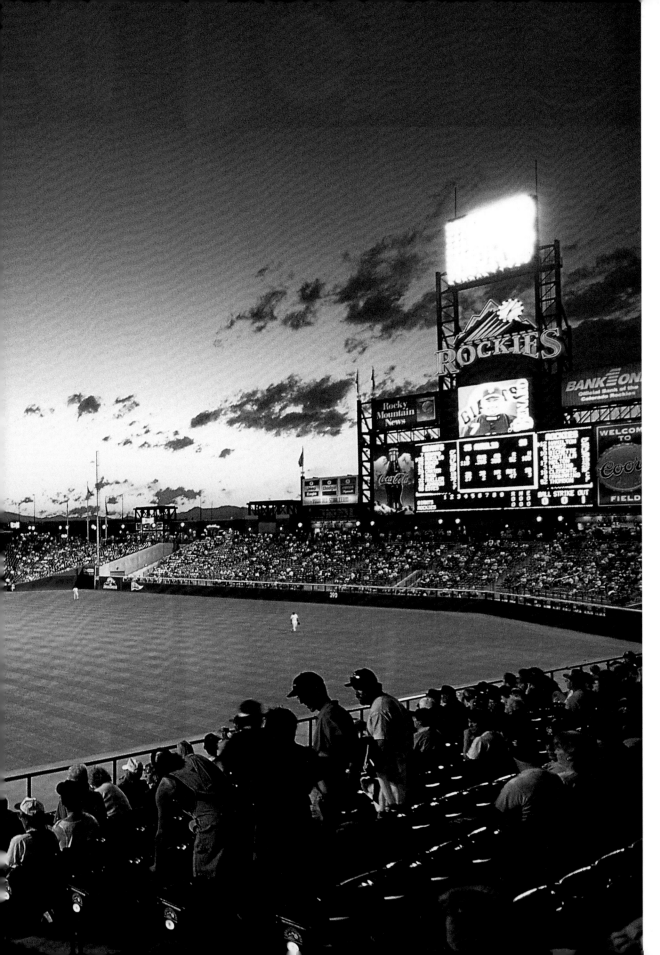

The wind and the altitude at Coors Field, home to the Colorado Rockies, have helped hitters set new records. With seating for more than 50,000 fans, Coors Field has also set attendance records since it opened in 1995. Fans seated in the upper section's twentieth row are exactly one mile above sea level.

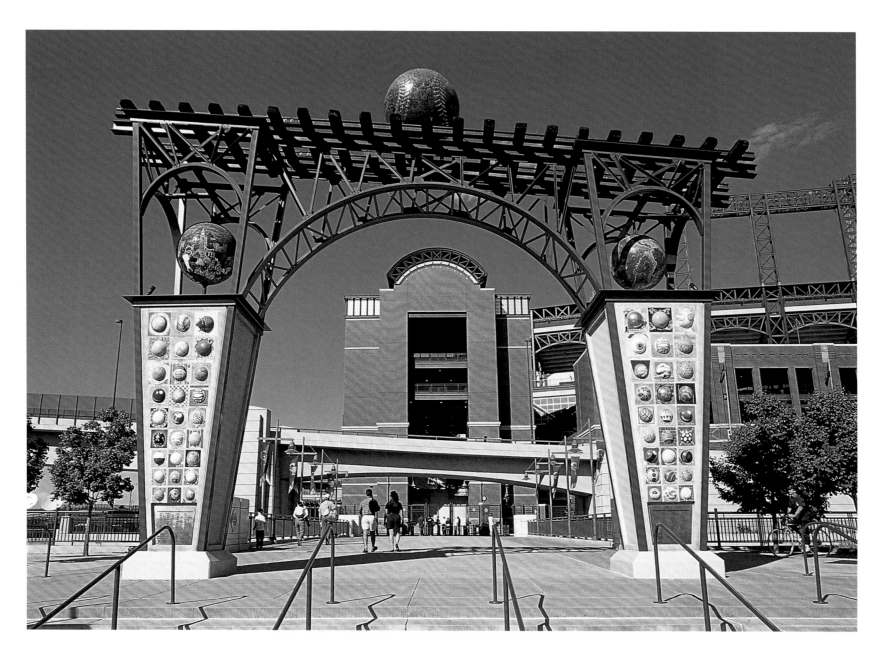

The entrance to Coors Field is hard to miss. Fans encounter *Evolution of the Ball*, a whimsical look at the development of the ball from the eyeball and the goofball to Lucille Ball and, of course, the baseball. Local artist Lonnie Hanson created the sculpture in 1995.

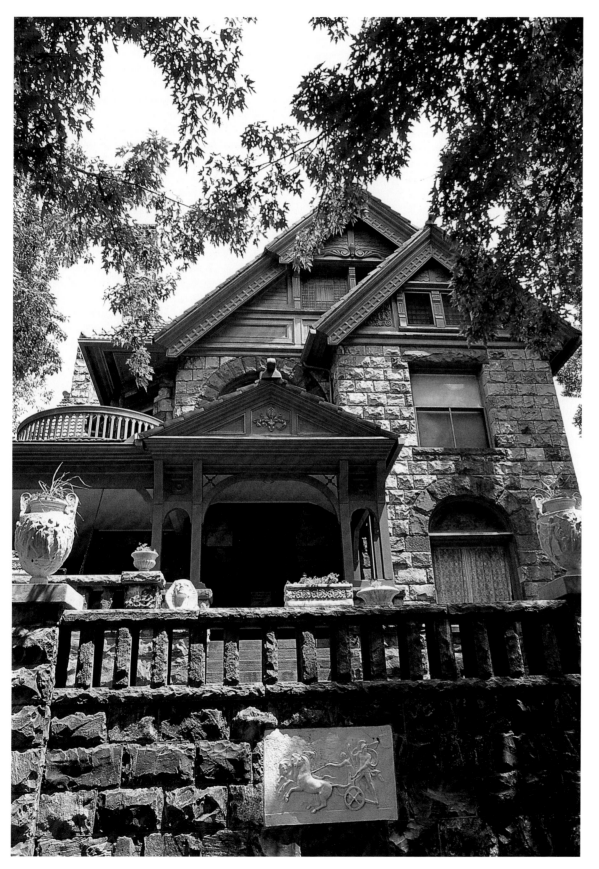

At the Molly Brown House, sightseers explore upper middle class life in Victorian times and learn about the life of Molly Brown, Denver's "unsinkable lady." Even before she became famous for surviving the sinking of the *Titanic* and raising money for others affected, Molly Brown pursued a life of philanthropy, as an activist for women's rights and the poor. She ran for the senate three times, before women had the right to vote in national elections.

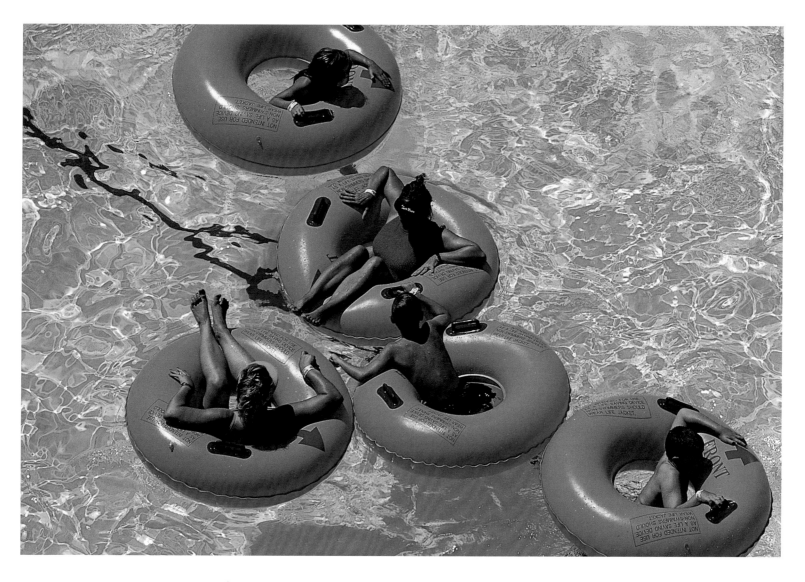

The Commotion Ocean wave pool is part of the Island Kingdom Water Park at Elitch Gardens. The park also offers water slides, a float down a meandering river, a lagoon, a tree house, and plentiful space for sunbathing.

With more than 45 rides and attractions, Six Flags Elitch Gardens takes days to explore. The Big Wheel, as the 150-foot Ferris wheel is known, gives a panoramic view of all the park's options, from the Great American Scream Machine roller coaster to the Runaway Mine Train.

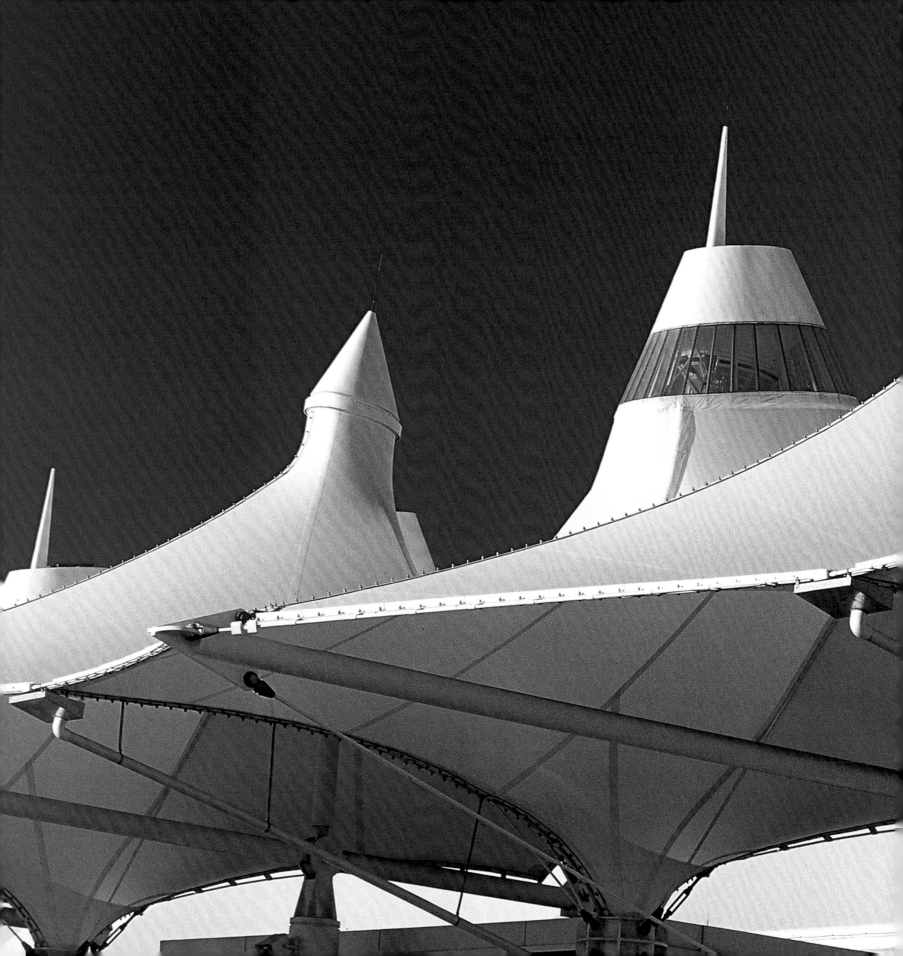

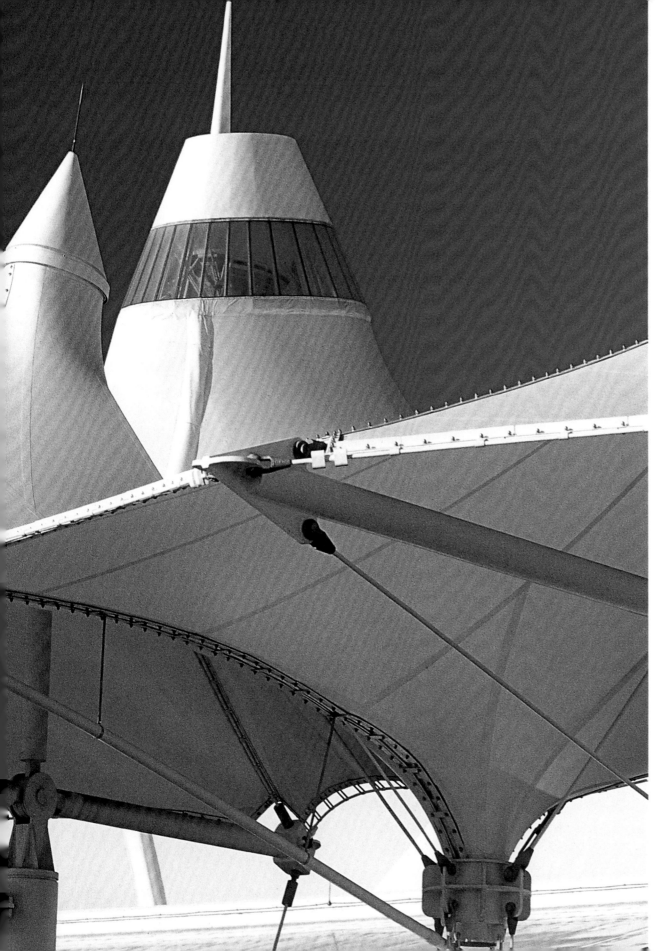

About 1,300 flights and 88,000 passengers a day pass through Denver International Airport. The 53-square-mile facility is the eleventh busiest airport in the world. The unusual roof is made of Teflon-coated fiberglass, which reflects the sun's heat but allows daylight to pass into the building below.

The central atrium in Denver International Airport's Jeppesen Terminal features soaring glass walls, allowing travelers a thrilling view of the constantly arriving and departing flights. The terminal is named for Elrey B. Jeppesen, an aviation pioneer. The navigational maps and charts he created in the mid-1900s are still used today.

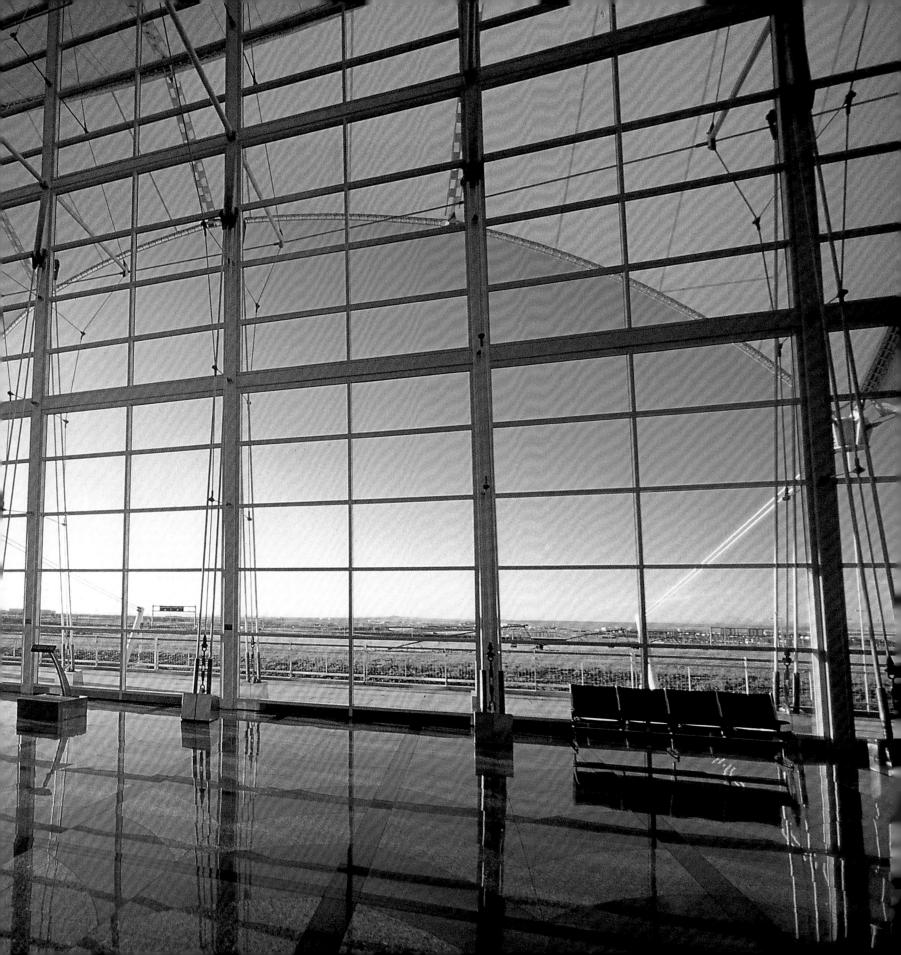

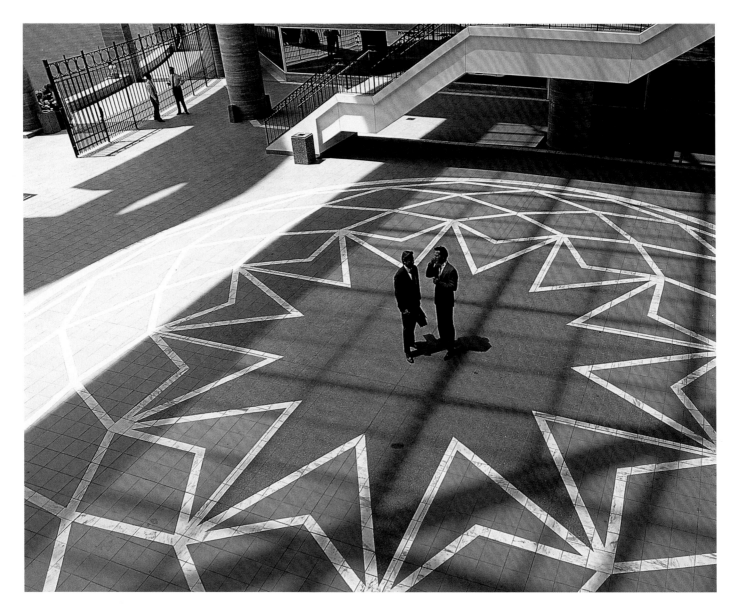

Just south of Denver, the satellite city of Englewood is home to more than 30,000 residents and 1,800 businesses. Like its larger neighbor, Englewood began as a gold-mining camp in the mid-1800s. The first homesteaders settled here in 1860.

Only an hour's drive from Denver, Rocky Mountain National Park protects a magnificent collection of snow-capped peaks, many towering over 13,000 feet high. More than 350 miles of hiking trails, along with winter cross-country ski and snowshoe trails, lead adventurers into the wilderness.

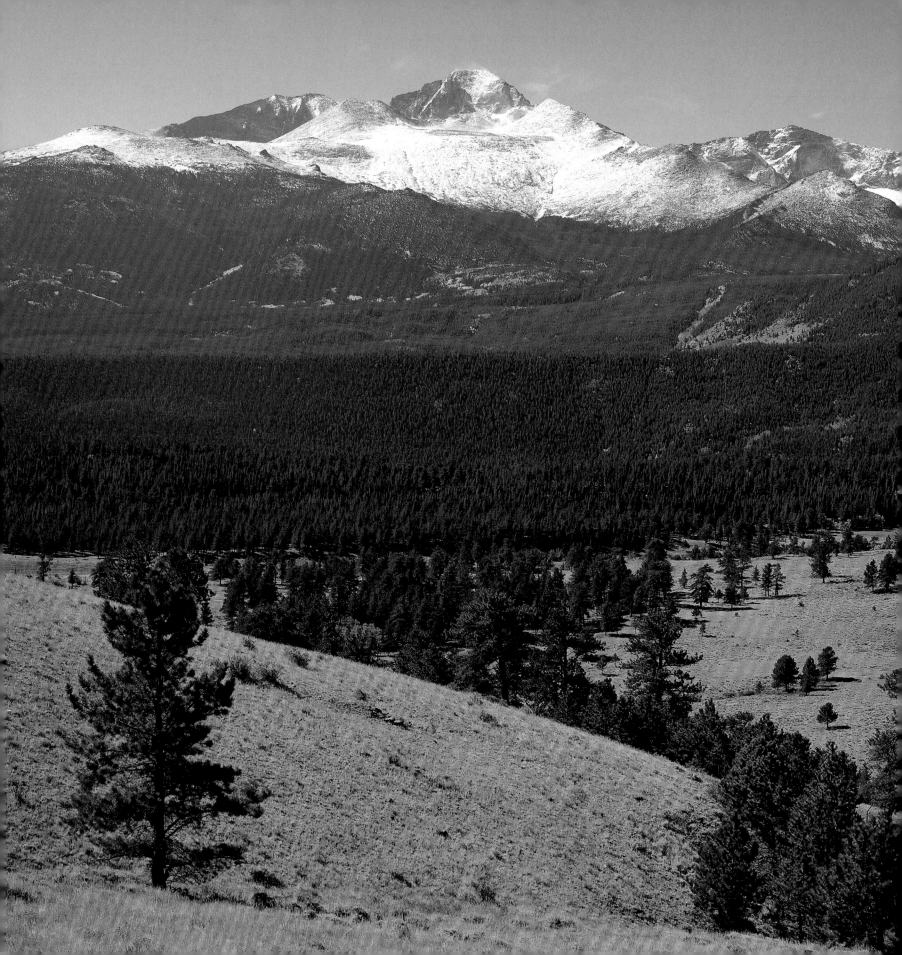

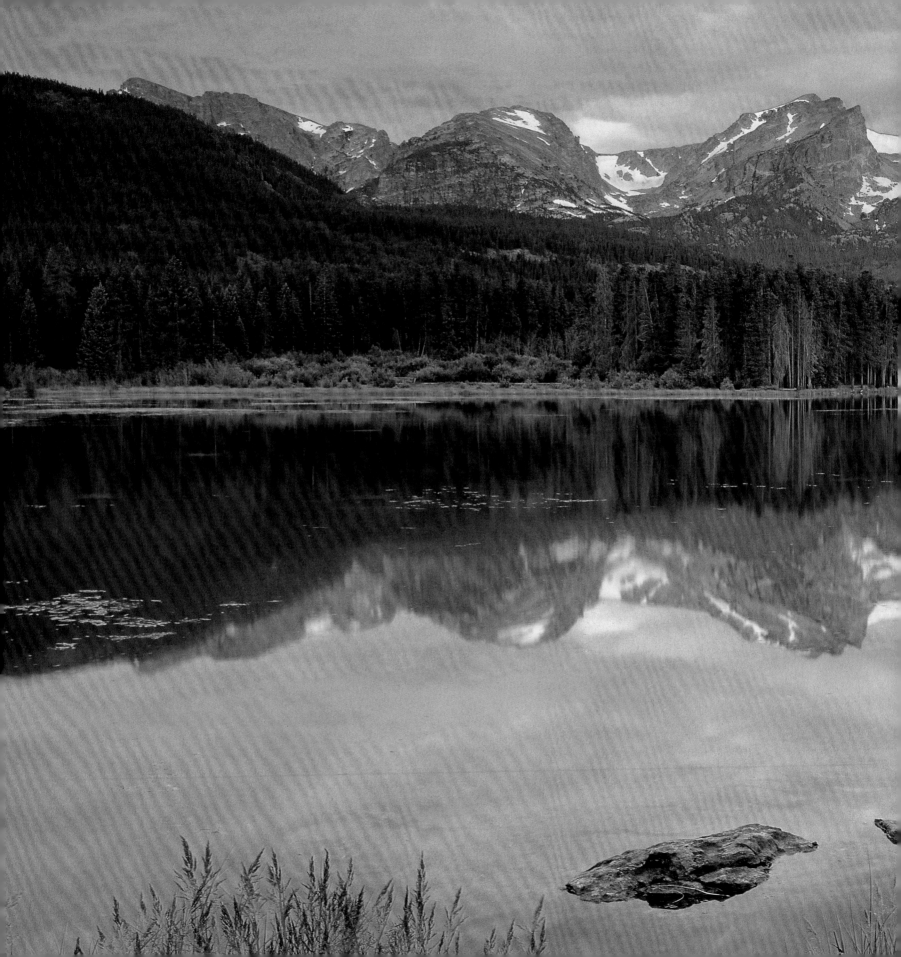

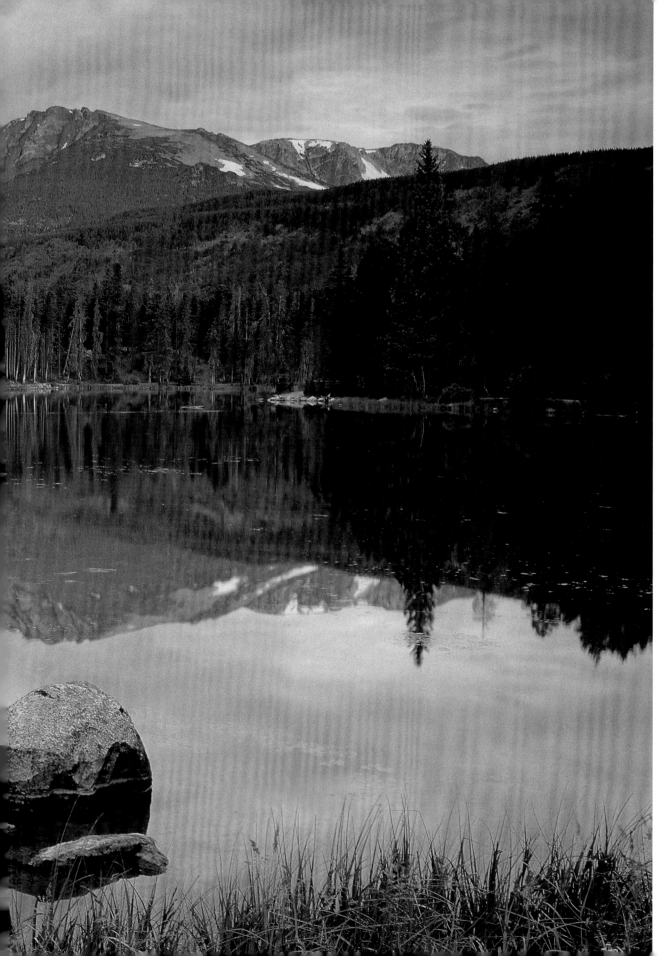

The movement of plates on the earth's crust created these mountains 70 million years ago. Land that was once a shallow sea, home to dinosaurs, was pushed thousands of feet above sea level. Today, the 265,769-acre expanse protected by Rocky Mountain National Park is home to elk, deer, bighorn sheep, moose, and coyotes.

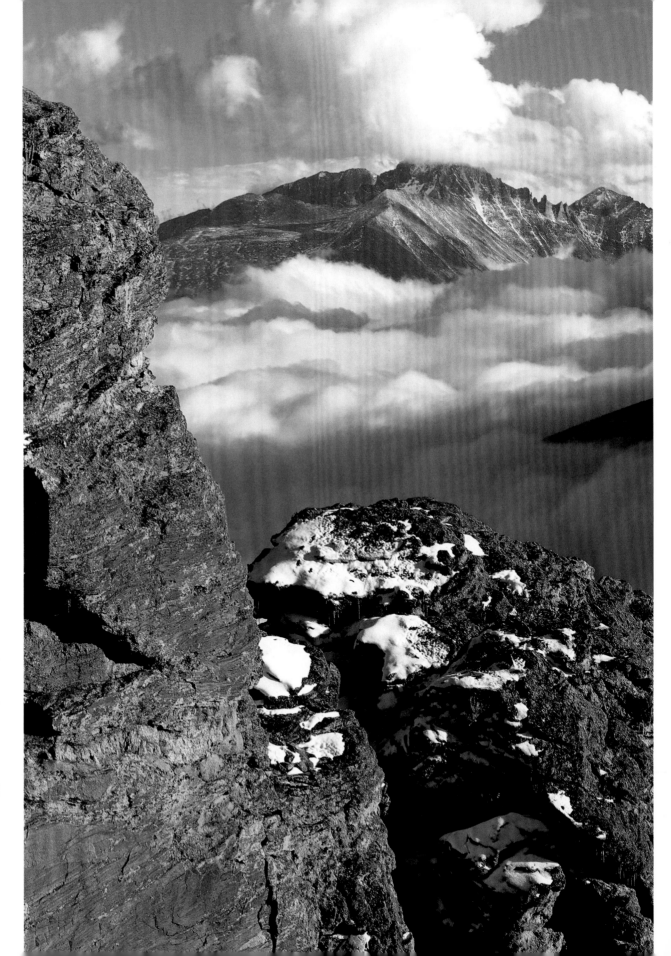

Hikers at Longs Peak face a 7.5-mile climb with an elevation gain of 4,850 feet. Most climbers begin the ascent before 3 a.m., to ensure they are off the mountain before the afternoon brings lightning storms and avalanche conditions.

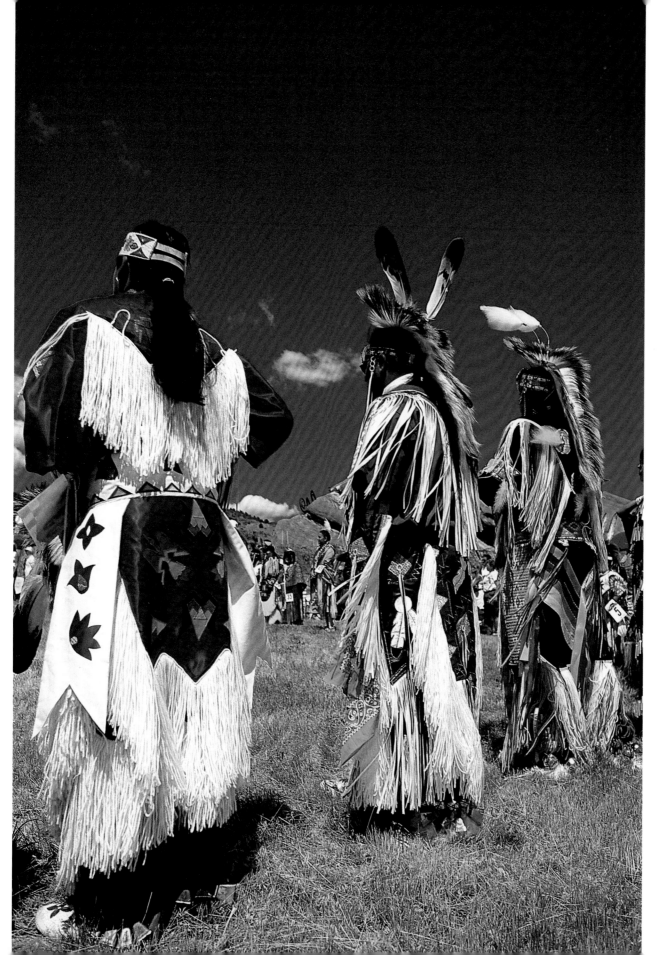

A powwow in Morrison serves to remind visitors of Colorado's native heritage. Thousands of years ago, the Anasazi people, sometimes called the cliff dwellers, built pueblo dwellings on Colorado's mesas. By the time the first European settlers arrived, the land was home to the Cheyenne, Arapaho, Comanche, and Ute people—hunters, farmers, and traders.

85

At 6,200 feet above sea level, this runner at Red Rocks Park and Amphitheatre has chosen a challenging training course. Among the animals native to the park are mule deer, mountain lions, rattlesnakes, countless small animals, American kestrels, and mountain blue birds.

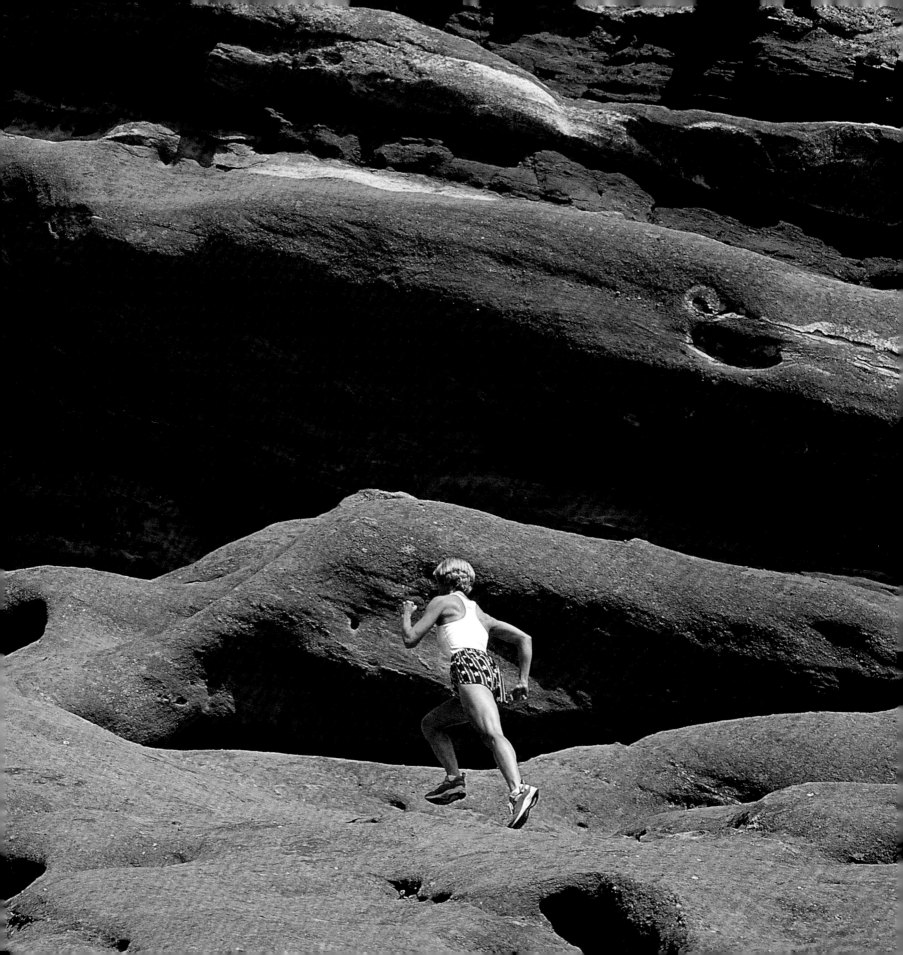

At Red Rocks Park and Amphitheatre, 15 miles west of Denver, two 300-foot monoliths shelter a natural bowl and create a venue with unique acoustic potential. Concerts and special events have been held here since the early 1900s, amid the footprints of dinosaurs and the fossilized remains of prehistoric creatures.

FACING PAGE
Winter ski weekends are a Denver tradition. Residents have countless hills to explore, from Vail and Breckenridge to this powdery run on Copper Mountain, 75 miles west of the city. Here, 125 runs crisscross 2,433 acres.

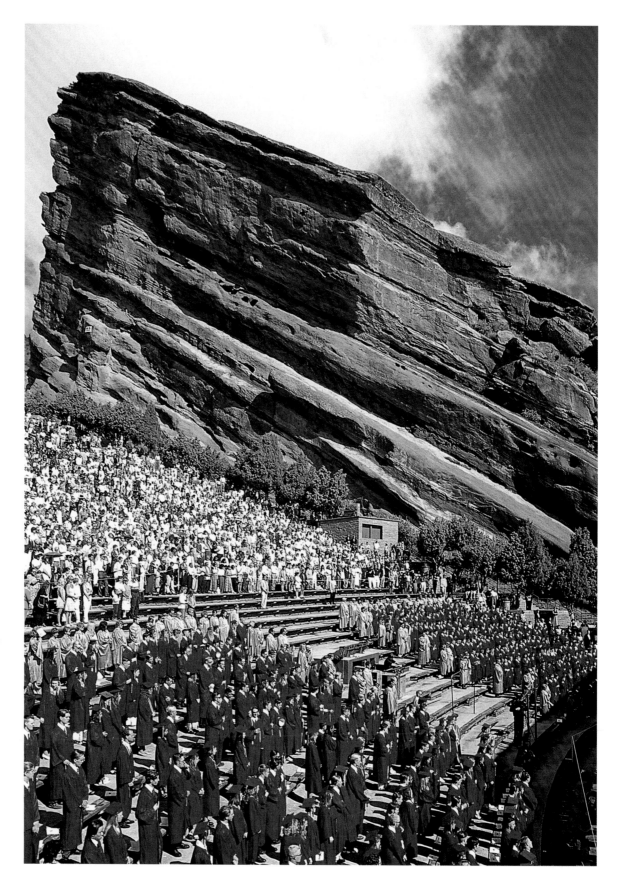

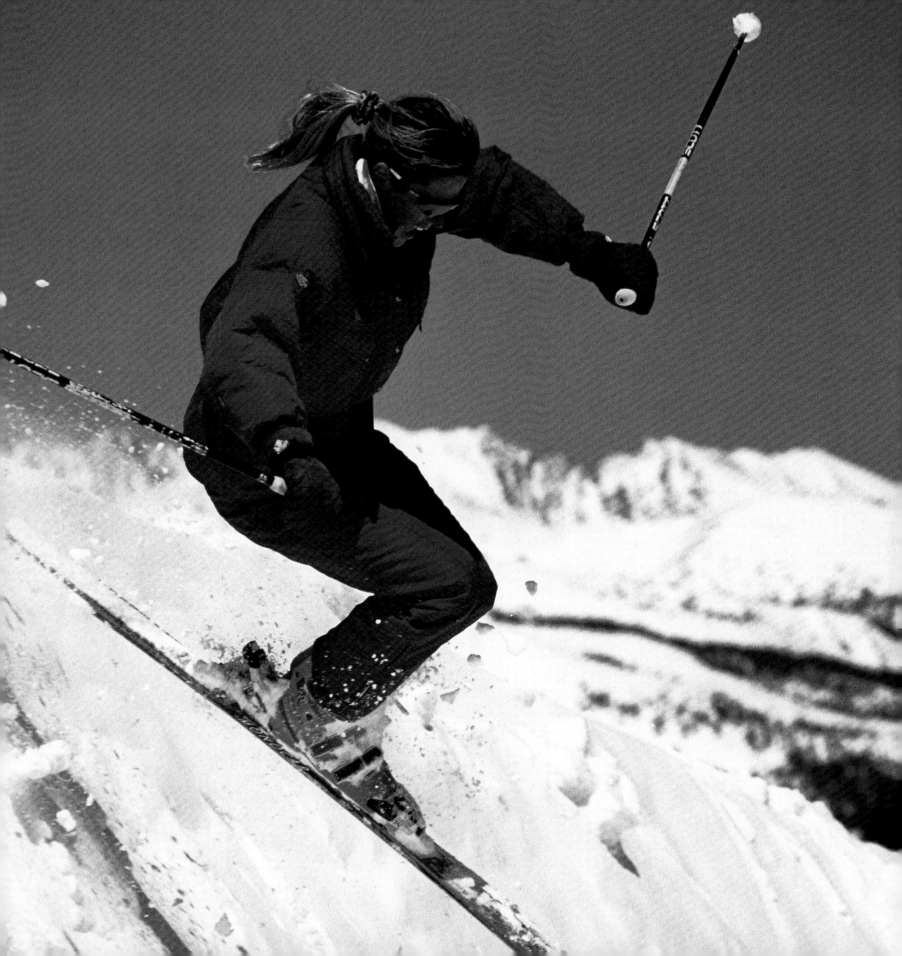

When the Georgetown Loop Railway began service in 1877, it wound its way up an elevation gain of 600 feet to serve the mining towns outside of Denver. In the 1970s and 1980s, the historic railway was rebuilt, including the 300-foot-long, 100-foot-high Devil's Gate Viaduct, where the rail line spirals up and over its own tracks.

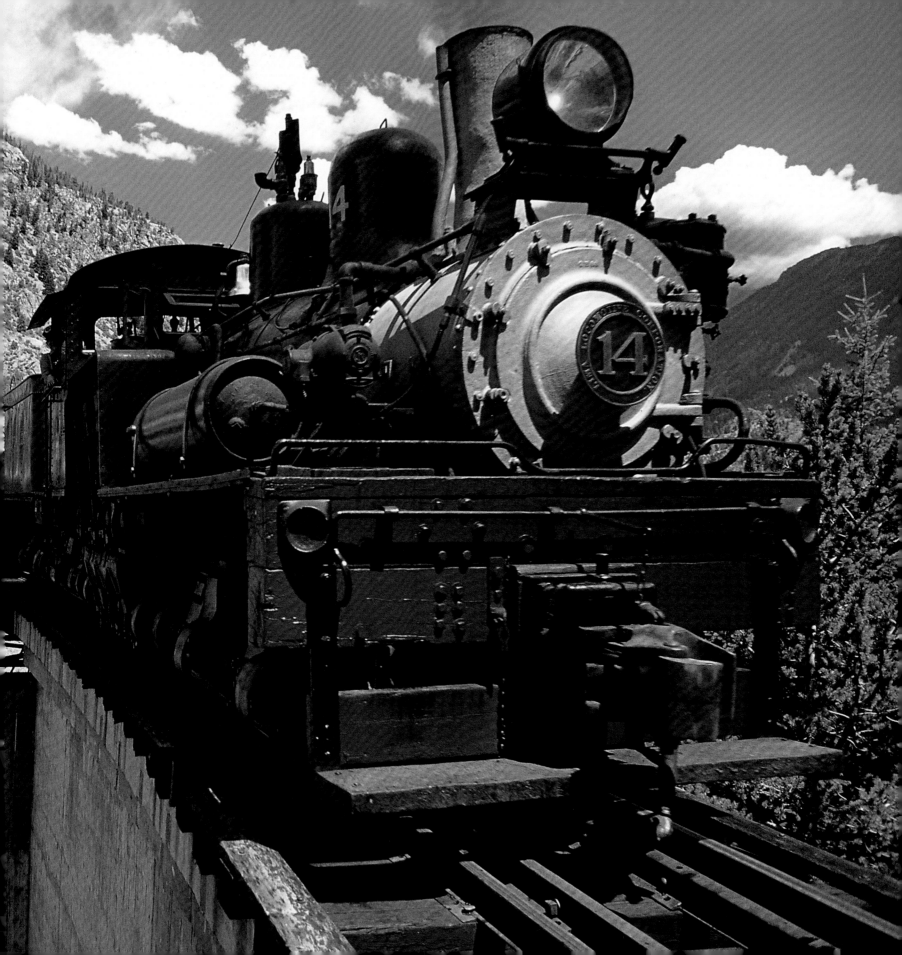

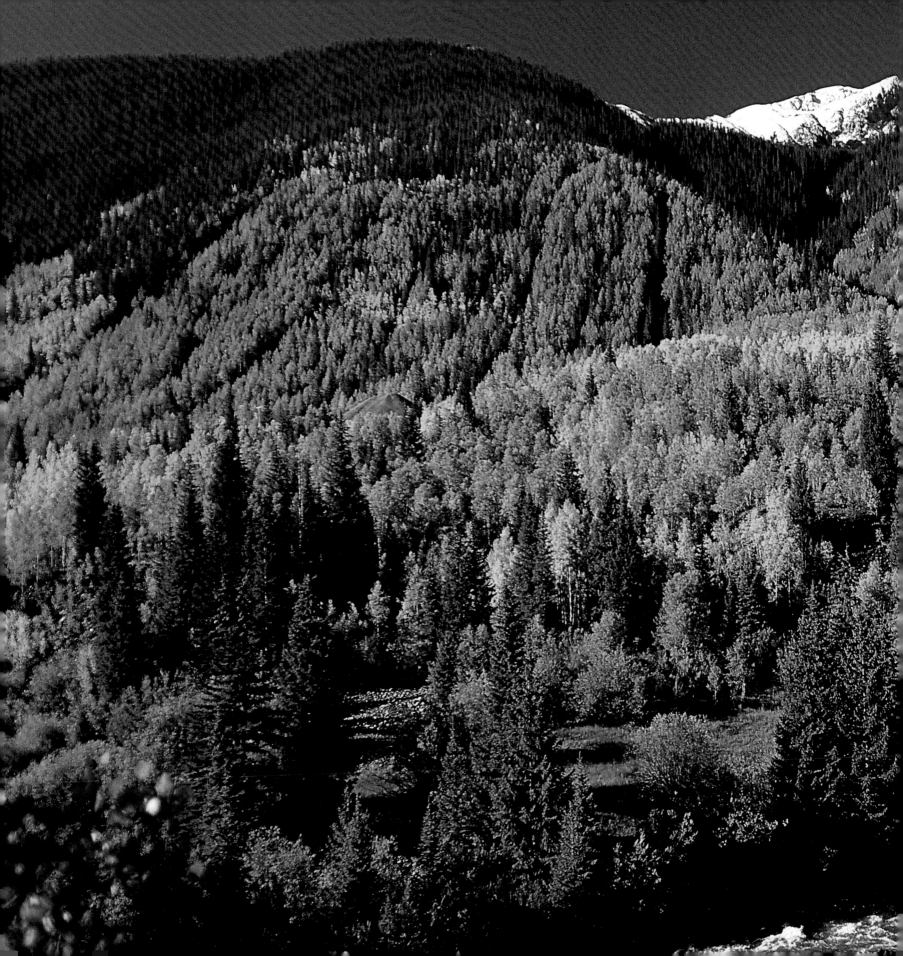

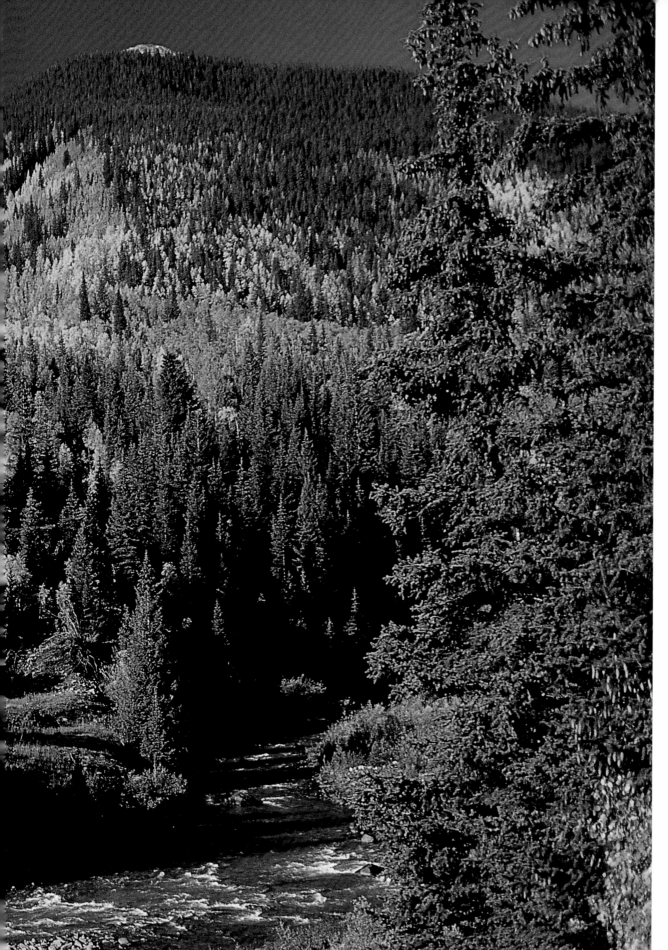

Colorado's average elevation is 6,800 feet, making this the highest state in the nation. The rugged mountain slopes such as these ones near Silverton discouraged early settlers, but they attracted prospectors to the region in the mid-nineteenth century.

The Pearl Street Mall is the center of city life in Boulder, home to the University of Colorado. Just 35 miles northwest of Denver, Boulder is the gateway to the Rocky Mountains and the region's rock climbing, mountain biking, hiking, and skiing facilities. *Outside* Magazine has ranked Boulder the best sports town in America.

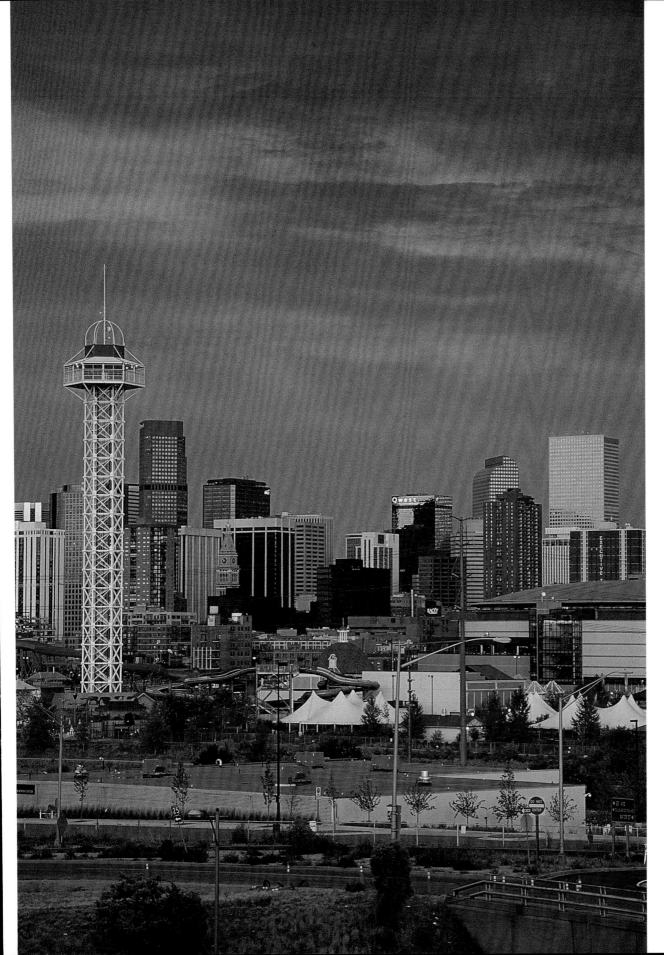

Denver's thriving economy is fueled to a large extent by the city's unique population. Colorado has the highest percentage of college graduates in America and is home to the second-highest concentration of scientists and researchers.

# Photo Credits

Terry Donnelly 1, 3, 6–7, 25, 59, 82

Richard Cummins/Folio, Inc. 9, 10, 11, 17, 26, 34, 37, 40, 41, 47, 48, 49, 53, 64, 66–67, 68, 72, 95

Walter Bibikow/Folio, Inc. 8, 52

Blaine Harrington III 12–13, 14–15, 16, 18–19, 20, 21, 22–23, 28, 29, 30–31, 32, 33, 35, 36, 38–39, 42, 43, 46, 50–51, 56, 57, 60–61, 62–63, 65, 69, 73, 74, 75, 76–77, 78–79, 80, 85, 86–87, 88, 90–91, 92–93, 94

Mark E. Gibson/Folio, Inc. 24, 54–55

Mark E. Gibson/Dembinsky Photo Assoc 27

David Falconer/Folio, Inc. 44–45

Kitchin & Hurst 58

Greg Gawlowski/Dembinsky Photo Assoc 70–71

Mary Liz Austin 81

Scott T. Smith/Dembinsky Photo Assoc 84

Todd Powell/Mach 2 Stock Exchange 89